T0014080

Advance Praise for *Wrong*

"A syntactically gorgeous page-turner, *Wrong Is Not My Name* demonstrates the ways in which art provides us with language to inhabit 'an archive of self and body, of consciousness,' and the lived histories that animate new visions for ways of being in an often hostile world. Here is a necessary and unforgettable intervention in the field of criticism that also doubles as a powerful narrative of self-unmaking. Erica N. Cardwell's critical memoir sneaks up on you with insights both tender and incisive."

—RAQUEL GUTIÉRREZ, **author of**
Brown Neon: Essays

"*Wrong Is Not My Name* is a tender, urgent examination of art, grief, and self. What's on the museum wall takes on new life, as if Carrie Mae Weems's Kitchen Table Series had a soundtrack. I loved being suspended in this smoker's sense of time, wandering the galleries of New York with what felt, at times, like Baldwin's lost daughter. Erica N. Cardwell peers into paintings at close range; her criticism has the intimacy of breath. This search for meaning is a means of enduring, an art in itself."

—AISHA SABATINI SLOAN, **author of**
Dreaming of Ramadi in Detroit: Essays

"To be a critic is to contend with dozens of expectations regarding what it means to experience art and how such an experience should be grappled with for a public audience. To be a critic is to contend with the idea that somehow this kind of work is always finding its end—perpetually in crisis or consistently irrelevant, depending on one's perspective. But when I read the essays that comprise *Wrong Is Not My Name: Notes on (Black) Art*, I am reminded that a critic can also be a person chasing after themselves and their histories, mapping the coordinates between love and pleasure, mourning and reawakening. To be a critic, as Erica N. Cardwell's writing teaches me, is to (re)negotiate a mode of relation that foregrounds the intimacies that shape who we have been and who we are so that we might learn to ask the difficult, complex questions about who we are becoming. She does this, of course, in the lineage and tradition of the Black women writers and artists who have preceded her: Blondell Cummings, Barbara Christian, and Willarena, her mother. Maybe then, what I want everyone to know, is that this is a book not merely about the conditions that surround the tasks of art criticism but that this is a book that invites its readers to peer closely at themselves, to trace the linings of life's griefs and joys, and to call forth the names of our people. Each act one of refuge, restoration, and art itself."

—JESSICA LYNNE, cofounder of
ARTS.BLACK

wrong
is not
my name

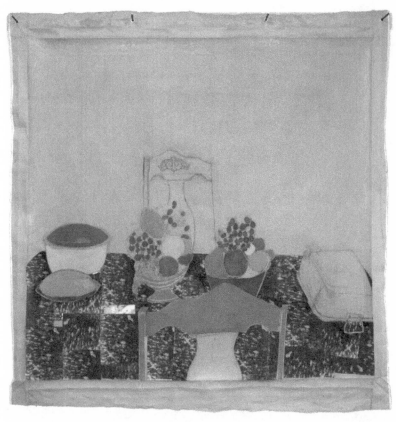

De Lujo by Genesis Jerez

wrong is not my name

NOTES ON (BLACK) ART

ERICA N. CARDWELL

THE FEMINIST PRESS
AT THE CITY UNIVERSITY OF NEW YORK
NEW YORK CITY

Published in 2024 by the Feminist Press
at the City University of New York
The Graduate Center
365 Fifth Avenue, Suite 5406
New York, NY 10016

feministpress.org

First Feminist Press edition 2024

 This book is supported in part by an award from the National
Endowment for the Arts.

 This book is made possible by the New York State Council
on the Arts with the support of the Office of the Governor and
the New York State Legislature.

 This book was published with financial support from the
Jerome Foundation.

 The author is grateful to have received support for this proj-
ect from the Andy Warhol Foundation Arts Writers Grant.

First printing March 2024

Cover art: *De Lujo* by Genesis Jerez
Cover design by Sukruti Anah Staneley
Text design by Drew Stevens

Library of Congress Cataloging-in-Publication Data
Names: Cardwell, Erica N., author.
Title: Wrong is not my name : notes on (black) art / Erica N. Cardwell.
Description: New York City : The Feminist Press at The City University of
 New York, 2024. | Includes bibliographical references.
Identifiers: LCCN 2023053125 (print) | LCCN 2023053126 (ebook) | ISBN
 9781558613812 (paperback) | ISBN 9781558613027 (ebook)
Subjects: LCSH: African American art. | Cardwell, Erica N.
Classification: LCC N6538.B53 C37 2024 (print) | LCC N6538.B53 (ebook) |
 DDC 700.89/96073–dc23/eng/20231204
LC record available at https://lccn.loc.gov/2023053125
LC ebook record available at https://lccn.loc.gov/2023053126

*For my parents, Willarena Cardwell
and Archie Bernard Cardwell Jr.*

"Blackness is an art, not a science."

—EMILY BERNARD,
*Black Is the Body: Stories from
My Grandmother's Time,
My Mother's Time, and Mine*

"Let's not decontextualize, defamiliarize, erase, diminish, bleach or blanch writing by Black women to make claims of canonical universality, or make of a Black woman's writing a theatrical repository for other people's projections, including my own. Let's revisit these works not as anthropology, or sociology, or psychology or ethnography, but as art."

—TISA BRYANT,
"'From Our Whole Self': An Intraview of Black Women Writers' Experimentation Essay on Elided African Diasporic Aesthetics in Prose," in *Letters to the Future: Black Women, Radical Writing*

Contents

Preface: On Adrienne Rich's "Diving into the Wreck"

A FEW DAYS after my mother died, I sat in the kitchen of our Pennsylvania home, across from her best friend, Cynthia. At the time of her death, I was twenty-one years old and about to begin my last year of college. Many of those evenings immediately following her death were a fog of near and far relatives, fried fish, and airports. Willarena was buried in her hometown, Dayton, Ohio, after the accident. Dayton is where she met my father, the place where my sister and I were born, and the destination of her drive. A memory that stands out is when I took a walk with my dad after the funeral. The reception was held at my godmother's house; Anita was another of my mother's best friends. The sounds of Smokey Robinson and Marvin Gaye flowed throughout her home from the Dayton Sunday radio that seemed to have been on repeat since my parents were young. I watched my father walk out of the front door and onto the sidewalk, weeping with each step. I ran to him and shoved my hand into his. *It's going to be okay*, I whispered.

Cynthia and I sat clutching cups of tea. My mother's spider plant wilted above us, curious about its next drink of water.

"You need your mother's diary."

I shifted slightly, exhaling a delirious laugh.

"Baby, do you understand?"

I nodded back at her, the edges of my eyes suddenly wet with a helpless sadness. I was a child. Every day felt like my first, but shallow from her absence.

"I know where it is."

Cynthia stood from the table and began to walk toward my parents' bedroom, as if she'd been there before and knew where she was going. I got up from the table and joined her, letting her guide me through the house I grew up in. As we entered the hallway, I recognized Willarena's footprints, embedded from years of her uneven pacing on the mauve carpet. My balance had been off since I learned of her death, but I managed to carefully slide into each step, trying to match my footprints with my mother's. I didn't walk into her bedroom immediately. I lingered in the doorway, suddenly consumed by fear. The bed was unmade and covered in a pile of her clothes. Cynthia skirted her way around it and walked right to my mother's desk. She opened the top right drawer. The drawer dangled inside the runner, displaying an off-white notebook with the pattern of pressed flowers. Here was her diary, between overstuffed envelopes and a pack of her True Menthol cigarettes, recently used. Cynthia gasped, pausing to catch her breath on the edge of the bed. She turned back to me.

"There are things you need to know."

Still in the doorway, I pressed my fingers into my palms, hoping to stay put. Cynthia snatched the diary out of the drawer and returned to me with wide, lunging steps. She placed the diary in my hands and pressed it into my chest; tears poured from her eyes and ran down her neck.

"Take this, baby. It's for you."

IN THE DECADE that followed Willarena's death, my life would continue in New York City. There are entire years that I do not remember. I floated through the streets locked in an immovable shock, numbed by questions that I didn't have the answers to. *What caused the accident? What do you think were her final words?* Family members and friends insisted that I was holding on for far too long and it was time to move on. I refused, hanging on tight to her death as a life source. I grew accustomed to missing her. Sadness became an acceptable state to live within. I attempted to combat this with small celebrations of her life. For several years, I had an annual fish fry and invited my friends over for mounds of fried fish, potato salad, and slaw. My mother made her presence known. One year, a card table filled with dozens of wine bottles and glasses gave way and shattered on the linoleum in a moment of passionate sacrifice only she could incite. Red and white wine leaked into every corner of the room as we all clamored to clean, still holding plates of fish and salad above our heads.

After I turned thirty, I began to read her diary. For years, I kept it at my bedside, fingers tempting the pages each night. I knew that I would find answers, but I was unsure of what I was looking for, afraid of what I would learn. Inevitably, the pages revealed fragments of what I already knew but had never been able to accept: My mother was a joyful, God-fearing warrior, with a history of mental and emotional discord. Therefore, my unrest was a predisposition that begged for resolution.

Instead of resisting, I must surrender to the storm. Writing is the investigation. I rely on her diary and the book that doesn't have my name, on a quest that promises to be futile. The most troublesome aspect of the unresolved is its reliance on the dead. The dead is the anchor, mired in moss and rust from the bottom of a sea of generations. My hope, in writing this book, is to rewrite my condition, for myself and for the ones who will follow behind me.

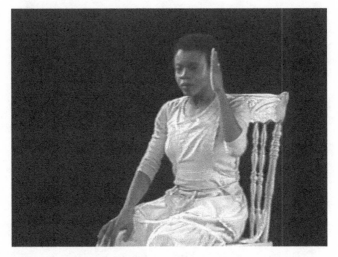

Blondell Cummings, *Chicken Soup*, 1983. Video still from performance
documentation. Copyright by the Estate of Blondell Cummings.

Chicken Soup: Seven Attempts

to say it happens, unaided, without sanction, would be untrue
—Ife-Chudeni A. Oputa, "Pathology"

– 1 –

THE KITCHEN ON Medway was our initial sanctuary. You know the place. Thirty-year-old appliances the color of split-pea soup, offset by wall-to-wall calico shag and a speckled Formica countertop. On the back wall hung a portrait of white Jesus (replaced by Black Jesus after my parents bought the house) and a corner placard pronouncing faith as good works. It was our first home after leaving Georgia for Maryland; the Northern subtext was never paid forward. Monopoly strewn across a glass tabletop on long Sundays meant for braiding hair and watching a roast—the kitchen was a brief depot in the narrative of who we would become. At the stove was usually where you'd find her. Cracking a frozen brick of turnip greens over a slippery strip of bacon, back leaning elegantly into the last drag of a True Menthol.

Willarena is cooking. It is end of day, and dinner will be ready soon. Once the greens hit the bacon, and the salt and fat steam into a low, rumbling whisper.

"Come over here and help me, Tallulah."

Tallulah was her name for me, a nod to the eccentric actress known for her husky voice and women lovers. I was an overly sensitive child, often perched near my mother's side. Tallulah Bankhead—a deliberate foreshadowing on her part and mine, which was a certain kind of mothering, the wisdom of prophecy in few words. With one hand bracing herself on the counter, Willarena reaches up toward the spice cabinet, tiny toes flexing inside white satin slippers, with only the slightest rise.

Maybe I walk over to the stove to provide relief after her long teaching day. I am taller than my mother, which isn't tall at all. Maybe I grab the shaker before she does so she wouldn't have to reach. With a few taps, the McCormick is added. Most of the time she beat me to it; I'd return to the table defeated, plump thighs pressed into the wicker chair. Most of the time we didn't speak until "Dinner's ready!" flew out of her mouth, pursed in agitation.

I need us to begin here, pausing to glance around at our invisible others. So many of us in this room, at this table. My mother's weariness held the work of many inheritances. The hand-me-down labors of tending to a home with passion while quieted dreams swirled within. Before she became a mother,

Willarena wanted to be an actress and a model. *My* inheritance—in which my name is Tallulah and dinner is cooking—was a wish.

I want to meander here for a while.

Postmodernist concerns of the domestic: coffee-colored stockings, Senga Nengudi's *R.S.V.P.* series, 1977; unclipped hairpiece, *Wigs (Portfolio)*, 1994, by Lorna Simpson; a stewpot, calling forth Blondell Cummings's *Chicken Soup*, 1981 (despite the actual cast-iron pan Cummings wields as prop); and a hand on the hip, none other than Jackée Harry's Sandra Clark, *227*.

Willarena scoops her usual small portion onto a saucer with a blue rim and retreats to her room, where the Julia Roberts rom-com *Something to Talk About* has been playing for some time.

Was my mother an artist?

When we lived there, I often felt as if we were living inside someone else's life, their home. My mother might have too. The house was covered in dated wallpaper with a pattern of round bodies in tubs of soap bubbles, wood paneling in the living room, and a wrought iron railing on a stone front porch. One main road hoisted up our neighborhood archipelago. Just behind our house was Starland skating rink. S-T-A-R-L-A-N-D glowed red against the dusk of weekend evenings. A grapevine threaded wild inside the pipe-thick eaves above the small patch of yard in the back. When I was a kid, those vines inevitably became a jungle within my fabricated worlds.

Today, white plastic fencing has replaced the rusty railing on the front porch. I would like to believe that the grapevine is still there, but I can't be sure. My adult glimpses have been during quick drives on winter visits, with one eye on the road and the other peering down the wide lane of driveway to notice the eaves now painted white.

My mother's kitchen, her stage, always allowed for a sacred returning. Much like remembering her, recalling the house is like conjuring a ghost.

Willarena sashays into the kitchen, another smoke between her fingers, hips sloping from side to side.

"Tallulah! Tallulah *Bankhead*! This movie is so good, Erica."

She pauses to make sure I'm listening.

"This white woman walked into this salon, where ev-ry-body was, and sa-a-a-a-id, 'If any of you has'"—Willarena pivots, whispering—"'slept with my husband, tell me *right now*!'"

She tosses her head, her words giving in to a vibrating snicker. The high pitch rings low as water leaks from her eyes. Pivoting again, she returns to her bedroom, still cackling and carrying on at this white woman's audacity.

Our house had two stories.

Not long after school began, my father received a phone call. He is to pick Willarena up from school because "nigger" is scrawled on her car windshield.

We all thought that this part was over. Back in Georgia, one of her student's parents was in the KKK and threatened to "come and find you after school."

I am a teenager when my parents buy a house on the other side of town. The dryer's edge is a ballet barre; my Discman plays Vivaldi. With sickled feet, I need to practice. The sound of the satin pointe shoes smacking, thumping, pounding against the slick linoleum in our laundry room resembles a child's applause. Up onto my toes, then down—toe, ball, heel. Heel, ball, toe. I can rarely sustain more than a few seconds up on my toes—legs straight, arms free. After a few rounds, I collapse into a pile of myself, shove my fingers inside the shoe, creating a space for my toes between the lambswool and the "pointe." I believe that if I create more space, then I can dance just like everyone else.

I am in the kitchen now, the newest one, with the linoleum floors. I am still in my leotard; my jeans are unbuttoned, and my tummy pushes out, full of pork chops and green beans. My mother always frowns at the way I wear my shoes throughout the house, heels tucked in, ribbons dragging behind me.

Erica, them damn shoes are too expensive to be dragging across the floor like that!

Her kitchen is bigger now. She is still tending to the stove. A pile of lesson plans sun themselves on our dining room table. Double doors open to a deck displaying dense pines and maples in a mysterious

thicket in our backyard. A wooden wishing well with a shingled roof nestles in the center, a leftover from the previous owner. Her gaze steady, she is grinning into my shiny black eyes. With a nod, she motions to a plate of black-eyed peas and greens on the counter before turning back to her work. *Eat, baby.*

– 2 –

IN 1982, the year I was born, choreographer Ishmael Houston-Jones curated Parallels, a dance festival that featured, according to the *New Yorker*, "[B]lack dance artists as living in two worlds at the same time."

Feared and fearless. Risky and unseen.

This cultured world, the worldliest of worlds, carried notes from Black American tradition: praise, affirmation, the blues. The other world was modernism, an art form or mode of thinking typically only allowed their white counterparts. But Jones was curious, specifically about the Black artists whom some considered to be different or, as he described them, "pushing the form."

Parallels showcased many up-and-comers— Blondell Cummings was among them. Her signature work, *Chicken Soup*, famously ends with her on the floor, her small hands clutching a sponge. They move back and forth, left to right. *Hands, no longer yours,*

contracted, owned, and directed by another, like a tool or an object.[1]

This cultured world, the *worldliest* of worlds, might not contain a kitchen table. When Cummings sits, she returns to what appears to be a conversation. She hears something. Is it us? Are we there? A nod, a wink, a glance tossed out into the galaxy of women in their kitchens. She is careful not to give the secrets away. From the back, someone calls her again. *Uh-huh!* she replies, pausing to listen once more. Between the thrusts of her body and sharp, gentle jerks from side to side, there is work. Ordinary work, lifted carefully and high into the light, newly born. Those few seconds of travel—from stove to shrug—are a passageway, correcting course.

Cummings jumps up to standing posture—appearing to convulse, but surely catching spirit. There is a pot on the stove. Soup is cooking. She lurches upright, stiffens her posture, then unfurls to an elegant height before collapsing back into her seat. Her movements are familiar—arms extended in front of her, then bent, and again, each gesture enlivens the composition. Attention blossoms each time as she raises the skillet high above her head, praising her portal for entry and allowing for her persistent return. A swing of her arm ramps up the motion

1. Saidiya Hartman, *Wayward Lives, Beautiful Experiments: Intimate Histories of Social Upheaval* (New York: W. W. Norton & Company, 2019).

as she hovers above her seat. The critic makes her edits: "The piece didn't take place in our house; it took place in *her* grandmother's house." But it also takes place in the kitchen. Rocking, washing, repeating. Listening. Tending to domestic chores has been inherited thinking space. Minding the making, what we imbue is just as important as where it came from.

As I write this, I am ironing my clothes before a fast-paced summer of teaching. I want to be prepared. Making too. What I finish may not be mastery but it is a signal. What is also there, what is beyond?

American academic Patricia Hill Collins understands archetypes to be "controlling images," a fastidious clarification for a personhood that could never align with the fallacy of institutional place.[2] Blondell Cummings describes her work as "moving pictures," a means of choreographing archetypes and allowing these controlling images to speak.[3] Chicken soup disturbs this perpetuity. Akin to mother's milk, chicken soup is believed to be a remedy. More potent, it contains that crucial yet hard-to-name something-or-other that can soothe the disparate ailments encasing our days in fogs of despair, or any achy restlessness. Blondell Cummings coaxed out the deeper complexity of domestic life; she allowed

2. Patricia Hill Collins, *Black Feminist Thought: Knowledge, Consciousness, and the Politics of Empowerment* (New York: Routledge, 2009).
3. Kristin Juarez, Rebecca Peabody, and Glenn Phillips, eds., *Blondell Cummings: Dance as Moving Pictures* (Los Angeles: X Artists' Books, 2021).

Black everyday life to become material, by taking us a few brilliant steps away to hover over the stovetop and see what's cooking. Her choice was crucial—the catch-all remedy, a solvent translatable across cultures and generations. Chicken soup is always a mystery in which the ingredients populate, and a bowl—steaming and fragrant—is placed in front of you.

Chicken soup, as location.

Chicken soup, as pattern.

Chicken soup, as distance—a reclamation of distance. I say, *This isn't about my mother*. I would rather call myself a critic to intellectualize and name my preoccupations—chicken soup, the kitchen table, this essay.

I might be asking: *How do I write this? Without her, my table, where do I begin?*

– 3 –

I LIKE THE way the word "kitchen" carries multiple meanings depending on where Blackness arranges itself in your life, your body. That soft coiled hair at the nape of my neck containing my history, sight unseen. A third eye. Or, of course, the kitchen where the food gets made and the conversations buzz. Some things solved, some things cast away, and everything else in between. Lorna Simpson's *Waterbearer*, with arms stretched wide in a dimension where history

and the domestic and my tender scalp all can sing. I go there to perform. To listen, bear witness. My consciousness resides in the kitchen.

The kitchen table as art object is itself a study of the feminine, both in praise and subversion of the domestic, a historic organizing principle—politicking and figuring out solutions, a haven for tarot, a potential archive for our delicious back talk. Carrie Mae Weems's *Kitchen Table Series* asks viewers to reconsider this legacy through the story of a young Black mother and configurations of her daily life. Her daughter, husband, or friends often gather, but quite poignantly she is alone, the table bearing witness to her deepest ruminations. In a revolutionary image work, the poet Morgan Parker places herself at the table, hair tied back, forearms tattooed, cigarette in hand in her collection *There Are More Beautiful Things Than Beyoncé*. These personas subvert otherwise flat archetypal intentions with more realistic depictions—a distance marker as postmodernist reach.

– 4 –

I WAS TWELVE years old the first time I made chicken soup. Puberty had rendered me quiet, and I often disappeared into a book. I wasn't feeling well, but I didn't have the kind of symptoms we usually look for. There was no runny nose. No headache or coughing.

There was no fever. I just didn't *feel* good, and I was growing more and more stuck inside myself. Chicken soup, as an act of caring for myself, might have been my first attempt at performance.

"Whatchya doin', girlie?" Daddy asks when he calls. His cheerful greeting informs a busy start at his office.

"Oh, watchin' TV." I walk away from the phone cradle, stretching the cord, and return to leaning over my pot.

"How are you feeling?" His gentle concern asks *if everything is okay*, assures *you can talk to me*. I wasn't one for staying home from school, but that day I woke up already filled to the brim, warmed over from thinking, barely able to dress myself. Both my parents were already out the door—their commutes required an early start. I am standing in front of the television, clutching a pencil. *Eventually*, I think, *I will finish my homework*. My hands need something else to do. "Oh, fine. Better." I am murmuring now, giving myself away for doing nothing.

"Now, don't mumble, baby." He pauses. "Have you eaten? There are some cans of Dinty Moore Beef Stew and Campbell's in there. Tomato soup."

"Yeah."

"Oh, you *did*? What did you eat?"

There is leftover chicken in the house. Soup needs onion, and chicken soup needs carrots and celery. Carrots get tossed in, along with last night's diced onion.

After a little while, I dump it all in, the vegetables tumble down to the bottom in deep splashes. Broth sizzles on the burner, forming small white bubbles. "I made soup." The word falls out with as little pride as one should muster for such a youthful accomplishment.

"Which one? I had beef stew for lunch."

"No. No, I made chicken soup." The white mug with the cascading red hearts holds a portion of the soup, steam rising into the air above me. I am leaning over the mug now, and my face casts a shadow—round cheeks and a long slender trunk of a neck on my petite frame.

"You made soup? All by yourself?"

"I don't know. I just made it."

When my father comes home, he barely loosens his tie before announcing, "Now I want to see this soup."

His was a charge, grounded in a request from me, that this soup was true. A twelve-year-old cooking for herself isn't necessarily a marvel, especially this twelve-year-old, but there was *mood*, and not enough information. I stand, still draped in the clothes that I slept in, and follow him to the kitchen, where he is already opening the refrigerator door with one arm resting on his thigh, head tilting from side to side as he scans for the soup.

"I threw it away," I say, placing both hands on the kitchen counter.

"You threw it away?!" His voice cracks and he turns his head quickly in my direction.

"It's in the garbage." I pause, moving away from the counter.

Laughter fills his tone now, his neck falling slack. "Why would you do that, girlie?"

"I don't know."

"Hmm." He closes the refrigerator door. Then, just as quickly, he breaks contact, to save himself, and reunites with his after-work chores. "I can't understand how someone would throw away something they made from scratch, for the first time. I would want to share it. *I* would be proud of it." His voice trails off as he continues to narrate his way through the house. I shuffle to my bedroom and sit on the edge of the bed, pencil in hand.

– 5 –

I WRITE FROM a wooden secretary. I found this desk after the first night I spent in my Queens apartment. Now there are black cigarette burns on its edges, noticeable when papers shift, memorable for the sentences I completed while a disregarded cigarette smoldered alongside me. The desk was accompanied by a bookshelf; they were left curbside, in front of the apartment building next door, waiting for me. Both pieces of furniture were conjured by my

anxious prayers the evening before. I was alone that night, slowly accepting that I had finally done it, that I had finally left my white farm town and made it to New York to do my Black soul some good. The decision to leave was an early belief in what is mine. And after many years in this sanctuary, I am now able to reflect on the radical quality of my departure, a physical enactment of the tight breath in my chest that could not be released, that I was unable to let live. And along with being a sanctuary, when I think about this, I realize that this apartment has also been a certain kind of prison. As I sit here and piece together my survival, seeking to understand my imagination and hoping to enjoy the rest of my life, I must accept that I have been here before, at this desk, recycling ways to hear myself.

My posture is terrible; one would never know that I was a ballerina. The pain in my groin causes me to slouch over my keyboard. My pelvis is tilted forward, which has created a knot that hurts when I walk or sit or stand. Or breathe. A massage therapist told me that it is common to have uneven hips; most people walk around this way, undiagnosed. My wife would later discover this knot while we made love, her hand gently placed in that nook below my pelvis, where my thigh connects to it. There was a curious look on her face, as if her hand were a tuning fork, and my groin, dense and emotional soil. *Something is in there*, she said.

Early days in New York satisfied my yearning for

a home. The air smelled new—it held a privacy that would soon construct my writer self. The apartment was waiting for me in the *Village Voice*. I spread the pages out on my bed and circled listings with a pen. We each put down eighteen hundred dollars to cover security plus first plus last, which I took from a summer of paychecks. I spent an entire summer looking for an apartment that would be my home for fifteen years. After ten years there, I will be told by a therapist that I stay too long at the fair, when I've returned to the arms of a woman who doesn't love me for one of many "last times." I crack a joke about lesbians and then shuffle onto the N train, water pooling in my eyes. I don't eat that night. I don't eat most nights. Instead, I pour a hefty glass of wine and drag my pen through pages of my journal—a taut, illegible record of grumbling loneliness.

Kitchen tables appeared in rotation. I can often more readily envision their shapes than I can their owners, my roommates. The longest one, with six grown-up chairs, arrived. We were holding it for a friend who couldn't fit it into her apartment. The size invited dinner parties. (Dinner parties were usually comprised of a "big egg," or a frittata with any vegetables we had in the apartment, or a pizza if someone ordered one, all shared over a bottle of cheap wine.) One look at the table summoned a practice that had been silent for a while.

Morning narrows my eyes; my temples tighten in protection. I am standing now, hips dropped in

motion, dallying between two worlds. As I move through the bedroom door, each step lifts me higher and more in cadence. I am walking to my kitchen, still seeking its rhythm. When I arrive, I am already moving with administrative precision, the saltshaker and any stray wooden spoons shifted slightly to the left before I can start the coffee.

On my list: *bananas, eggs, fennel, cardamom, aluminum foil.*[4] A friend described my apartment as a ballet studio: the square symmetry of a warehouse, with a bay window, stark white walls, and all tile flooring—brown, oblong "flowers" from the seventies, like the smelly carpet in the house I grew up in. I began to track the presence of living in two worlds.

I prepare an elaborate performance, squandering the tips I earned from waitressing: baked salmon topped with capers and butter, edges curling from the tartness of lemon. Collard greens accompany the salmon, a carefully cleaned and blanched sauté decorated with white onion and sweet yellow pepper. Bold rings of acorn squash are on another plate, the leathery green rind wrinkled into a softer, more palatable suede. Next to the squash on a red plate are wedges of brie, its ooze quickly rendered inedible by the summer heat. I am in the habit of backing away from my table to enjoy a lonely cigarette, onion

4. Tucked into my copy of *A Lover's Discourse* was a folded Post-it with a list on it: *almond milk, coconut yogurt, confectioner's sugar, mushroom barley.*

bits trapped between my fingers. I amble down the hallway to my bedroom, forcing my invisible party guests to wait until I return to start eating.

I forgot the bread.

The baguette is lying on the counter's horizon, a span the length of my arm. I return to cut the loaf into diligent diagonals before setting it into its angled places around the salmon-collard creation. A bottle of wine, missing a few glasses, always completes the welcome table. Arms folded, I examine my work, letting a bit of cigarette ash land on the streaky tile. In the glowing light of a late summer afternoon, evening begins—itself a soul serving someone else's life.

I inch toward the kitchen table with careful steps, pausing briefly before I begin to scoop every still-warm bite into plastic containers. I work swiftly against the heat reddening my hands, lemon juice dripping, fish finding its way beneath my fingernails. I let the fridge door slam behind me, finishing the job, the lids from the containers warped toward the steaming, mushy cadavers.

"WHY DON'T YOU try sitting down and enjoying the meal?"

At the time, my therapist resembled a more-than-middle-aged Joan Didion (ironically, she was unfamiliar with Didion's work): wiry, with legs that wrapped around each other like pipe cleaners from a child's collection of arts and crafts supplies. It was

the Wednesday after the salmon meal. It was always a Wednesday after a meal. Each word was accompanied by fast blinks behind her wide-framed glasses, her demeanor in sharp contrast to how casually I spoke about the situation. I spoke the way one might recall their weekend plans to the person standing in front of them in line at the supermarket. She wrote in almost vertical scribbles, using a different notebook every session. *Why don't you eat, Erica?* Hers was a new thought. *Eating after cooking.* I repeated it to myself. This was never considered, much less a reason for my ritual. Cooking was about the labor. The work was more important than the results. I was surprised that my therapist regarded this as unusual. But as soon as she said so, I realized that I sounded like a lunatic. The kind of lunatic who prepares enough food for a family, only to have it rot and congeal into untouchable waste, never having tasted it. And even worse, I was a broke lunatic, foolishly wasting my funds on this habit.

"That's an interesting idea." I chuckled, wishing that she would stop writing. *Look at me*, I thought. My laughter told me that I deemed the finished meal unimportant, not some delicious bounty worthy of being shared. Or eaten, for that matter. I was skipping the pleasure altogether.

She smiled, uncrossing her legs for a moment, making her black-and-green polka-dot socks more visible, before recrossing them. The Empire State Building could be seen from the large window of her

co-op apartment near Union Square, a bright pink needle in the sky.

"Do you think you can try that this weekend? If you decide to cook?"

I could see her considering the diagnosis of an eating disorder. *I'm a cook*, I thought, suddenly feeling hungry.

"Have you eaten today?"

– 6 –

AT THE JEROME Robbins dance archive in Manhattan, I watch for the first time a video recording of Cummings's *Food for Thought* suite performed at St. Mark's Church. In spite of the videographer's steady hand, the POV is affixed to the flitting light of Cummings's body in motion. Despite the professional quality, the tone is undeniably that of a home movie. Fittingly, my chair is broken: I am seated at the lowest point, my knees bent high enough to touch my elbows. Grace Paley's short story "An Interest in Life" narrates the background with a food diary: *wilted lettuce, two moldy dried-up lemons, tightly wrapped Danish bleu cheese, flat seltzer water—* circuitous threads coursing within my subconscious. I find myself leaning further back, my short legs dangling as my feet lift slightly off the floor. Another person has arrived at the library's circulation desk— it is time for the shift change. *Sorry, I was in a rush*

earlier. Her colleague follows behind. *I was carrying groceries, and they were heavy.* When they speak simultaneously, the words collapse into one sound, elaborate contents of fridges catalogued by roommates and lovers, and a routine family dinner. *My mother never joined us.* Briefly inert, I am thinking of my own bottle of carrot juice, my whole-grain bread, rinsed kale, and leftover spaghetti.

<div align="center">

— 7 —

</div>

LIVING WITH LOVE invites other voices. I am unable to keep up. My resistance shows itself on Saturday mornings. I'm up whisking eggs. Z meanders in, bleary eyed and light, reaching for me. I lend a kiss but tip into flames when she begins to touch things. *Would you like some coffee?* she attempts. I recoil, clear in my rage. *This isn't how this should go*, we both must think.

My home evolved into a collective of working lesbians, artists, and queer people—a nontraditional household that allowed us all to thrive: the destiny, perhaps, of this place. When Z moved her belongings in, she made the reluctant decision to live in an archive. Dirty dishes. Food caked on handles, and pots stored away with stained lids. Dusty bookshelves and years of artwork lining the walls. I am no longer alone. Our lovemaking is surrounded by the ghostly objects of those who came before, an

addiction that gained momentum after my mother died, exactly one year after I moved into this place. The ghosts that live here are not only memories of those who have come and gone; they have taken up residence to protect me and anyone who enters. While this may be a gift, there is also a tension, the burden of caring for these artifacts. Before Z, my kitchen persona was when I was most alive. Tending, preparing, initiating for my family, even if alone.

Like me, Z is haunted. Initially we followed the same instinct. It's strange to think that food and sex could scratch the same itchy desire—pulling taut grief's frayed edges. "Queerness," a fitting word for such terse ambiguity, divorced from faking it, or asking. We fucked with our mouths full. Yes, "queer" is the word, and "clarity," too. My urge toward confrontation dwindled, and then a year later her mother was diagnosed. Anger coiled around us as we made love. Humming, her yearning clung to me. We were in a different house. Our shoulders battled—warm and wet—the smooth skin of our familiar intimacy. *Home is in your arms.* We hadn't showered, fragrant in our helpless longing for each other's taste. My shirt crumpled over my breasts. Above me, her hair yarned the tense air as she charged my body. *Are you sure?* She covered my mouth. Voices knobbed around in the kitchen and living room below us. I was messy on her fingers. Different ghosts—those eyes, both present and burdened, begged me to never leave her.

When she moved in with me, the air was tight. The sway, the disappearance, the ability to let one's soul rest is where I find cooking again: a tense collision of the woman for whom I will never again cook and the woman to whom I have committed many meals. Z stands to turn off the lights. I set a platter of chicken between us. I yearn to clutch my plate and slouch off alone. She smiles calmly. I shuffle away to grab a sweater, hollering to *start eating before it gets cold*. After we make love, Z rests her head on my thigh and gazes inside me. If all the food from the first half of my life were to suddenly materialize, whole pinto beans, long ropes of spaghetti, and uncooked eggs would parade from between my legs. Her brown eyes lift to the ceiling between slow sips of water. I return to the table.

Considering Gabrielle Civil's "On Aftermath"

ARTIST AND EDUCATOR Gabrielle Civil describes this moment as the "Aftermath." These are the moments—hours, days after a performance—where one feels summoned into a new realm of being. Very soon after 9/11, Civil debuted *art training letter (love)* at Babylon Café / Cultural Arts and Resistance Center in Minneapolis. The performance included a ritual in which a recording was played of a letter Civil sent to her friend, the artist Madhu H. Kaza, on September 21, 2001, very soon after the World Trade Center attacks. The letter describes an affair she had with a Moroccan man, an intimate encounter she continues to mull over. That night, the man disclosed how surveilled his life had become after 9/11, forcing a strained relationship between himself and the world, as the police state began to infiltrate his every interaction. The performance contained a lot of questions; Civil describes the feedback as "between intimacy and catastrophe." One of her friends, who was also the emcee at the opening event, went so far as to say, "I don't know how *that* was related to 9/11." Civil considers:

Some aesthetics are about fusion—some are about thought—some are about that meticulous faceting of experience, a kind of filigree, some are about blowing things up, magnification, disintegration, but for me—at least then—it was always about want ... or at least that's what I think ... what I wanted to say then ... what I am wanting to say now ...[1]

Soon after I moved to New York, 9/11 occurred; a year later my mother passed away. I was a sophomore in college. Near the end of that school year, I overheard a young ballet dancer on a pay phone. Her bun was held in place by a white hairnet. She was speaking to her mother, sobbing in a stark display. *I can't be here, I can't do this*, she said, *I can still smell it.*

I have wondered about the shift in consciousness, of the short time I was in the city before it would be forever changed. I wonder about those twenty-one years with my mother before I would be without her. *After* her. Not the period of clarity where hindsight yields lessons. No, here, we are without shape—squirming and warm within this new self. In the tangled aftermath of my mother's life, toiling inside of domestic recreation, I devised a language.

Fumbling in the dark, I learned to work with what was left behind.

1. Gabrielle Civil, "On Aftermath," in *Swallow the Fish* (Civil Coping Mechanisms, 2017).

Thunder
After Adrienne Rich

what, if anything, survives
 —Christina Sharpe, *In the Wake:*
 On Blackness and Being

"YOU'RE STANDING TOO close, you guys." The guard's fresh manicure cast a cherry-red wave in front of her chest. Henry stood with his arms gathered behind his back, his face barely an inch from the crumbling surface of the Rauschenberg. I was next to him, rocking from toe to heel, neck craned in the guard's direction. Faster than I could apologize, sis had already walked back to her post.

The underworld, according to American painter Robert Rauschenberg, contained audacious characterizations of the American idealism found in postwar advertisements depicting congenial white American family life—mechanical smiles suggesting goodness. "Violent" might not be the word Rauschenberg would have used, but the inference is hard to deny given the excessive performance of normalcy. Each drawing in the series puts forth a grand energy despite its 14½″ × 11½″ size. Rauschenberg dove headfirst into his rough technique of soaking

magazine clippings—*Sports Illustrated, Time, Life*—
adhering each image with solvent (initially turpentine
and lighter fluid) to paper and then pressing it down
with the head of a ballpoint pen. From there, he
would take a pencil or crayon and fill in lines and
shapes. The magazine images, already toothy in
their macabre reconstructionist resolve, were now
memorialized in distorted abstraction under the title
Thirty-Four Illustrations for Dante's Inferno. Never
having read Dante's *Inferno* prior to beginning this
series, Rauschenberg had constructed a set of "rules
for engagement" for his process: topical, impression-
ist, observational. This project began as a way of
understanding his instincts for abstract study and
the nagging question of whether there were more
ways he could approach his work.

"The problem when I started the Dante illustra-
tions was to see if I was working abstractly because
I couldn't work any other way or whether I was doing
it by choice."[1]

Rauschenberg's interest in process would prove
informative. Museum trips had become a favorite
outing for Henry and me. It might have been fitting
to liken us to Dante and Virgil, a pair journeying
into the underworld on intimate, unspoken terms.
Yet I was, and still am, convinced that Henry was
more of a Dean Moriarty beatnik type: both were

1. *Robert Rauschenberg: Thirty-Four Illustrations for Dante's Inferno*
 (New York: MoMA, 2017).

giddy, pensive fellows with soft hearts, tripped up by a sense of solemn unrest and a commitment to never give that away. In my romantic world, Moriarty existed as a conflation of everyman ids, an enthusiastic vessel for sensitive outlier white male masculinity. Henry was a manager at the restaurant where I worked, and we were always being scolded for talking more to each other than to the customers. He favored white button-downs with the sleeves rolled tight at the elbow paired with blue Levi's and polished black leather boots that *click-clack*ed during his manager rounds. In my memory it is always summer, which meant secondhand dresses with high necks and floral patterns were my typical fare. It had been just a handful of years since my mother died, but I was already accustomed to people assuming that I didn't understand complex things—people rushing through explanations and the meaning of words and their most proper pronunciations; the tone was a bit different now. People were watching me. And I couldn't figure out if it was out of concern, if something was wrong with me, or if this is how it always was. Much of what I recount here is out of order—locked inside of the muddiest early phases, moments that arrive like a fleeting new idea you forget to write down or a very strange dream that quickly dissolves into hazy inarticulable orbs. Facing death reinterprets. Previous constants morph into crude and haphazard intuition displaying itself, a feeling strong enough for me to follow,

but strange enough to keep me tucked away for days and weeks at a time. Fittingly, Rauschenberg's investment had always involved a "test"[2]—surely process over product, but also embodiment. What becomes of the work when the process is exercise? Forget about art for art's sake, but art with the sheer intent to learn.

"You gotta step back," the guard repeated, with a slight hint of agitation.

Flushed red, Henry backed away. The worry on his face surprised me—if not for the thrill, what was he looking for? It's an easy symbol; the project provided Rauschenberg with inadvertent preparation for his forthcoming "Combines," a deep study for which much of his process could be newly approached. Rauschenberg also used colored pencil for these drawings, a fact that Henry encouraged me to take notice of. He emphasized this by leaning close enough to nearly graze the canvas with the tip of his nose. I had never seen anyone get that close to art before, let alone in a museum. I followed his lead, getting close enough to feel my breath against my face.

Imagine being close enough to a painting that your pupils dilate and you no longer can see the art. Is this what the artist sees? This is now a somewhat ludicrous learned habit I enact to the dismay of anyone around me. Which is why I often see shows

2. *Robert Rauschenberg.*

— 28 —

alone now. Still, the closer Henry leaned, the more I followed.

"I'm so sorry," I repeated over and over as we moved in front of the next painting. The second time it happened, she was still kind, but now she was smiling too.

"She likes us." Henry was playful. Again, relaxed.

Henry had this incredible capacity for love. So much love that he only started running to get closer, not away. To keep me from being alone, but to also have a companion in all that longing. A potential byproduct—the regular presence of sweet, handsome lovers who waited for him after work. I and the rest of the waitstaff breezed past their strong-backed good posture, our trays stacked high and noisy from wiggling coffee cups. I was raised to perform, and now, wielding the superpower of grief, I had to step in. I had only faint, cinematic ideas about love and was still acting them out the way I did as child. A damsel kissing my wrist in practice sessions, my silly lovesick heart bellowing like the chimes of a grandfather clock.

Whenever Henry called, I could be shy and knowing at the same time. I could ask questions or explode into a rant of half-baked ideas. More than a friendship, Henry always kept an eye on me, lighting my cigarettes with a conflicted look in his eyes. He'd take a long pull from his own, flick the lighter in my direction before leaning into his hip. A cup of coffee was usually hanging by his side as white smoke

slowly released from his hooked jaw. My mother was there, in the form of this curious journeyman, a living messenger. Together, Rauschenberg's technique inspired, but Henry and I were curious about a world right before transformation.

Grief had formed a school around me, a place of study. Thick was the despair, but I found myself renewed in the presence of creative expression, a fresh, hungry wanting yet to be named. My early focal point was theater. I could disappear into piles of plays for weeks at a time, only emerging to talk incessantly about them. It was at this time when most of my conversation skills landed like clownish, unrelated opinions from the brassy mouth of a child. No one could receive me. And no matter how close I stood, I kept finding it harder and harder to connect. Folks would call me a poet, laugh a little to themselves, and then proceed, often repeating what I said in different words. If not for privacy, it was *easier* to disappear into my room. Some days consisted of a loud rolling over to behold the ceiling's sky and make music out of the remains of afternoon sun. Most months were spent with theater. For instance, Luigi Pirandello, the Italian modernist, had removed the stage altogether with his *Six Characters in Search of an Author*. I was fascinated with the technique, the anchor coming untethered, the roots of a self and the performers waffling around a bit lost. I read others: *The Balcony*, *Fefu and Her Friends*, *Waiting for Godot*, and strained classics

by Chekhov, Shakespeare, Eugene O'Neill, giving myself an education. I didn't always know what I was reading but I wouldn't stop. Now and then, something clicked.

The shape of my body formed a cocoon. Small within this fortress, I peered back at the dispositions and expressions often unable to behold me. I flailed within this reflection, an initial disorientation that pushed me to form myself into another's likeness. And as ill-fitting as those clothes were, I lost years roving within this futile task. My difference was unavoidable. Announcing itself in every aspect of the person I was becoming. The more out of step I felt, the more I had come to realize that this had always been my place. That I was born in this separateness, an outsider whose double consciousness formed a thirdness, clamoring forth, unwilling to be tamed. The poems from these long days into nights exhibit the tension of these warring selves, the knowingness and the refusal.

The room, a grungy imitation of Diane Martel's pouty '90s music videos—plush fabrics, faux pearls draped all around, and piles of pastel sheets—but with more blankets, less color, and teetering piles of books. It might have been an unmet need that turned me into a writer. This undisturbed period of self-study allowed me to shove my hand into my navel and pull out the creatures squirming and babbling in languages only I could decipher. When I would finally leave my apartment, I would make my way to a coffee

shop and spark up a conversation with a stranger before any other part of me could resist. Evenings were a long dance sequence to the percussive tumble of "Little Girl Blue." I was practicing my arabesque, balancing my extension on the windowsill. On other nights, I would thrash inside of my sheets—a mess of improvised squats and gestures answering the vibration of my skin's song. Days continued that way, plodding forward in extraordinary disharmony—a cosmopolitan soundtrack to the fallow blankness at my core. It will always be a strange thing, to have someone you don't really know tell you that your mother was your best friend, a platitude more prevalent in the absence of her body. An already gaping mouth yanked wide, sputtering nothing. The act of mourning, of being folded upon myself with unbridled sorrow, was not the whole of the emptiness. Cleaving for her body, for the presence of her small stature and tiny reaching voice, invoked an unabashed ache for her *conversation*. I remained profoundly wordless, yet strangely, compulsively literate.

Being alone in New York made me eager for this tension: a willingness to observe desire troubled by a willingness to pursue risk. Reading provided a brief underworld. There was action and drama and energy and conflict, from what I considered to be a safe distance. And when this grew tiring, when I could no longer ignore the roiling heat within me, I would return to friends whose lives had continued moving. Their interests were the typical yearnings

of early adulthood—falling in love and beginning their careers. I tortured myself in fitful attempts at kinship—going on uncomfortable dates with men and weaving tall tales about the aftermath. A family-owned video store was located down the block from my Astoria apartment. It was less than a block from the twenty-four-hour fruit and vegetable markets, United Brothers, at the corner of Thirty-Third Street, and Elliniki Agora, where I could get my fresh herbs and wild mangled mushrooms. On the Saturday after payday, piles of customers sampled leaves and bruised fruit as they tested for ripeness. But at the video store, there was a warm, curious vibe shared by many of its customers. Romantic comedies and foreign films were perched smartly in the center aisles: Godard, Buñuel, Almodóvar. The blockbusters lined the walls. I would rent an Almodóvar film and a romantic comedy and, every single time, believe that the ending would be different. That the initially unrequited wouldn't come to their senses and fall in love.

A glass of cheap wine
green curry from Yajai
chicken fingers from the Mini Star diner
combo number three from the JJ's sushi,
the best sushi in New York.

I was lonelier than I should have been, a frail, shivering reed with anger hanging heavy in my

sight line. Outwardly, I was growing into a too-thin woman held up by a forced smile. I found a photograph of myself, somewhere between twenty-one and twenty-four. My eyes reveal that the blinds had been drawn for an undetermined amount of time. My smile is that sly one—resigned to her dissatisfaction; my hair is wrapped in a yellow-and-red scarf. The look in my eyes does not appear to be one of loss or sadness. I look committed. Time will often construct wisdom, or something like it. I have held on to that boldness, only now it has come to mean something more shy, timid. Still bold but awkward seeming— fumbling with even the information I have come to learn through experience.

I began poring over the Beats, mainly its cult of women writers, willing to confess the problems with these so-called heroes. Hettie Jones's life thrilled me—she made shadows around the East Village in vintage floral skirts and big eyeglasses. Eventually, her love, LeRoi Jones (Baraka), courted Diane di Prima, my other favorite. I went to St. Mark's Bookshop a few times, imagining their silent showdown, a scene from Hettie Jones's *How I Became Hettie Jones*, between the stacks.

Crammed under my bed lived C. S. Lewis's *A Grief Observed*, PhD applications, a copy of *Motherless Daughters*, and my mother's diary, my most sacred text, untouched. Hinging within my bedroom's sky was this enormous overgrowth of decay. An aching presence in the form of sepia-colored mold, furry and

replete with return. Another doomed "Giovanni"—abandoned but unable to die. A daily reminder of the self I wouldn't let leave. The existential task required a sloughing off to make anew. In the absence of being seen by my mother was a new intention. Being "seen" by art. How could I make this change? Could I revise?

In Rauschenberg's case, the move from collaged abstraction to media-based imagery came via Dante.

—Leah Dickerman[3]

DICKERMAN DESCRIBES THE photo-transfer paintings for *Dante's Inferno* as "second-generation printing," a means with which one will repurpose or reinvent what was already there. In most ways, when one looks upon Rauschenberg's "Combines," it is evident that his urge to make art was a kind of self-study, primarily insular and unintended for consumption, and that the Dante illustrations informed his later work. Poet and teacher Adrienne Rich describes this as "re-vision,"[4] or the examination of who we might have been before as a means of reckoning with who we have become.

"Re-vision" is to visit again. To sit with what has passed and ask more questions.

3. *Robert Rauschenberg*.
4. Adrienne Rich, "When We Dead Awaken: Writing as Re-Vision," *College English* 34, no. 1 (1972): 18–30. https://doi.org/10.2307/375215.

THE WORD "CRITIC" didn't fit, at first. Potentially irre-sponsible, the hodgepodge of pleasurable arts and culture predilections displayed more of a passionate and inquisitive amateur than an expert. My room, a salon of plays and poetry, art prints and photographic film, might sound fitting for a critic. At that time, this collection was a medicine meant to sooth the turgid pull of grief, to keep my mind prickly and preoccu-pied. I had to keep my cup full of art. I would pore through an initial binary of taste—high and low, fine art and entertainment, *New Yorker* and *Time Out*—to test, understand, gain a position, a perspective.

To that end, being an art critic has always been about what I could learn. And because of how wrong this felt, to be a curious Black woman in spaces where everyone feigned knowingness, I didn't think I could measure up. I started with the institutions that centered Black art: the Studio Museum in Harlem and the Sikkema Jenkins gallery for a while. The origin stories of some of our most exciting critics rarely had anything to do with mastery and always involved a quality of the self-made. I'd concoct these short write-ups on my blog—the unofficial explora-tion was fun because it was illegitimate. And despite its "public" nature, I wasn't at all invested in having others read it.

The 2007 Studio Museum artist-in-residence exhibition, *Midnight's Daydream*, featured their resi-dents, Demetrius Oliver, Titus Kaphar, and Wardell Milan. I went alone, shivering as I waited at the bus

stop for the M60 to cross the bridge, directly across the street from Neptune Diner. Upon arrival, I made a beeline to *Battle Royale* by Wardell Milan. Working with the boxing scene from Ralph Ellison's *Invisible Man*, the artist displayed young Black boxers spliced and overlayed in paper applied with gouache. This technique of repurposing an image already laden with history and context appealed to me. I found the mix of older images with newer techniques to mirror something about me. Milan's work collapsed narratives into his own version of an otherworld, one that involved the "sacred and profane" of celebrities and messiahs, queers and clergy—in a fascinating quip that the binaries that exist in reality are actually one and the same. *Battle Royale* offered a more literal connection with a legacy that aligned with where I came from.

My blog was called *The Omnivorous*. A word for what I believed myself to be. Writing about art meant writing about everything.

Post from October 2006:

Fresh and fertile, fall art fall!
Infinite Island at the Brooklyn Museum—A sprawling exhibit of 45 artists from 14 Caribbean nations declaring themselves as the rightful owners/originators/sinners of the projected getaway.

Midnight's Daydream at the Studio Museum—Three male artists in residence

(Titus Kaphar, Wardell Milan II, Demetrius Oliver) tug aggressively at past marginalized ideals, displaying their relevance. If these are my compadres as I stomp towards the future, I am slightly at ease.

STANDOUT: WARDELL MILAN'S series *Battle Royale*—Collaged photos based on boxers from *Invisible Man*—vulnerable objects for a captive audience.

In the exhibition essay for Wardell Milan, the artist Glenn Ligon magnificently captures Milan's impressions as a "revisioning." Writing about art elongated my thinking, something to wrap the sopping overthink around, the concept of the mirror as windowpane, finally able to see the other side. The reflection was familiar, if also fearful. I would have my most well-timed anxiety attacks before going to a gallery, a manifestation of this openness. No one writes grief books for Black girls, no one could predict that an obsession with images and their reflections in my life as a potential grief practice would also make me scared of myself. Soon I recognized my face again. Lips full, resting under doe eyes.

Writing about art was incidental, not accidental. I can't say it wouldn't have been anything else. I began to allow my writing about art to be a process of recognition. I started inviting elements personal to me. As I was already immersed in various lines

of inquiry, this constituted an impressionistic, lyrical source of curiosity. I don't claim to be very good at writing about the visual in a traditional sense; this has never interested me. What I mean to say is this: to live as if we are entitled to our sense of belonging is a violent aim; it requires other people's shoulders. I write, in this way, right now, to continue to see. Like Wardell and Rauschenberg, I am fascinated with the "second-generation" painting, *re-vision*. To see, to make, in collective response.

"Re-" as prefix. Refuse, reform, renew. Again.

ANOTHER VERSION OF me walks in the room, and I sit and consider her posture, her easy smile, the way she drinks her water from a glass. Barbed verse tumbles out of her mouth, *thunder*, speaking to another me, the one inside. These lyrics, samples from the underworld.

THUNDER (the Gemini)—May 2008
I see your hand reaching for my thunder.
Exhausted thieves spend lifetimes dodging
 guilty rain clouds.
Your smile does nothing to mask your crime.
I cracked your eggshell façade and spoke all the
 words you hate.
Honesty love faithfulness.
Your eyelids wrinkle as you continue to reach.
Still present, yet in the dark, seeing only the red
 beneath your lids.

I don't stop you, and cowardly claim "reasons."
This glory will not comfort my thankless hard
work.
You have taught me to find new ways to brew a
storm.
Clutch my knuckles without touching my
fingertips,
While making me feel good about myself by
doing what I say.
Threaten my thunder to thoroughly defeat you.
Force me to rumble to discover my enemy.

At first, all my writing came out in bad poetry. A rhythmic wave—undulating, tangled half thoughts. The words arrived in fragments, unstitched edges of adulthood reframed in a child's metaphor. The speaker insisted on collapsing *into* images, moving pictures, determined to shake out the air, a blanket flung clean.

This poem indicates a presence. Amateur for its literal tone, but exigent in purpose. A shift has occurred. The speaker notices something. An unannounced assailant, an unfriendly ghost— an inert nuisance. *I see your hand reaching for my thunder.* I can remember a lover who had been taking advantage of me for several months (months as long as years in those days). The poem came out in one sitting. The consonance invites softer syllabic phrasing. The tone rarely flickers.

Exhausted thieves spend lifetimes dodging
 guilty rain clouds.
Your smile does nothing to mask your crime.

The speaker responds to being surrounded by domi-
nance. Something without a name. The presence
of the personal "I" is there but not there. The "you"
appears more crucial; I was beginning to under-
stand the project of "earning the I." Not value-based
labor, intent on making the writing process a mode
of production. Rather, to enter poetry, trust must be
built. This poem demonstrates a young relationship.

I cracked your eggshell façade and spoke all the
 words you hate.
Threaten my thunder to thoroughly defeat you.
Force me to rumble to discover my enemy.

For as much as the poem is talking to someone else,
the speaker is very clearly deriding themselves.

Clutch my knuckles without touching my
 fingertips,
While making me feel good about myself by
 doing what I say.
Threaten my thunder to thoroughly defeat you.
Force me to rumble to discover my enemy.

The arc of the "Thunder" poem is present in
much of my other work, my life. After a few "reviews"

I was talking loud, laughing louder, bursting. I was fitting in well in my city, barking out my orders before entering the room. To build your imagination is to begin to develop a trust relationship. The "I" conveys attentiveness. Not giving it away. "What does the poem *need*?" Or in other words, how can you tend to its desires? My "I" is not the sole means with which we communicate the Self. I could now see that the "I" in this poem was a collective "we." A chorus of voices, a speaking with, an address. In the absence of conversation with my mother, how do I continue to speak with her? In what ways was she the art that I coveted, my most intimate relationship?

If re-vision is feminist pedagogy, then the act of re-vision is a womanist tool in action. In what ways do the griefs of this world require us to wake up anew, write that song and assert larger questions?

Re-vision, if reclaimed, is an aesthetic of diaspora. Of histories we glean and form but, rather than construct, we revise.

The act of loving oneself. Uninvaded, reclaimed.

Re-vision as an act of not knowing or un-knowing.

Re-vision as an act of forgetting.

When I return to the question *Was my mother an artist?* I want to ask, *Why do you need a reason?* The question announces a greater need: What was my mother's everlasting question? And so I felt a powerful sense of needing to be alone and to also need that loneliness to be surrounded by art. I could only

handle interactions with friends or people if there was conversation, an idea to explore, which Henry was up for. Staying hungry kept me from disappearing. Others noticed. "This is a good length for you," a friend chimed.

WHAT IS AN encounter when we inhabit experience for art?

On a whim, Henry bought a used Jeep. It cost him $1,000, or two weeks' pay. He was pleased with how quickly the Jeep shuttled paint and stretched canvases between his walk-up in Astoria and the Greenpoint studio, just across the Pulaski Bridge. Much faster than the subway—easier too. Henry chuckled at the thought for the first few weeks after he bought the Jeep off the guy in the Navy Yard, a little beside himself with the relief of it all. The Jeep was a dark, flat green, a wobbly stick shift. Sometimes it took a long time to start after the ignition had been quiet for a while. When Henry called one day to see if I wanted to get some breakfast, he didn't wait for my answer.

"Babe, I'm coming to get you."

It was one of those mornings where the heat preceded wakefulness. Henry always frustrated me with his insistence—*I'm on my way*—an overzealous tendency I despised in myself. Pickled from the previous night, my lips puckered into a knot orbiting my face. I raked my fingers through the now thinning sheets as I rose to face the blurry

sight line between my bed and bathroom. I brushed my teeth with a hyperindignance, arm contorting back and forth as spearmint foam drizzled down my chin.

"I'm not ready yet."

But the Jeep wouldn't start again, and Henry was running late. I was sitting on my couch now, wondering if I had enough time to lotion up my ashy knees. My apartment spanned the length of the building's top floor. It was Friday morning and one of my roommates had already left for work; the other was stirring. I could hear the subtle twinkling of her alarm, a sound mimicking the animated sunrise from a cartoon.

Henry leaned on the horn as soon as he turned onto my street. I stood quickly and bounded my way out the front door. I knew he couldn't stop the Jeep—it trembled as he slowed down. His left arm clutched the steering wheel as his right arm stretched across the passenger seat. With just a few gallops, I hustled my way down the cement front steps, landing at the bottom with a dusty bounce. I'd been carrying a vintage sequin clutch meant for fancy evening wear as my everyday purse. Each step imprinted little half-moon shapes inside my armpit as I jogged alongside the moving vehicle. The engine sounded like a bolt had been let loose in the carburetor, clanging to Funkmaster Flex's Power Hour on Hot 97. In a swift move, Henry hooked his arm around my right hip and scooped me into the car, planting a warm

kiss on the top of my forehead. I could feel the craggy roughness of his exhaustion.

"Hey babe," he gasped out with a giggle.

"Hi," I replied, leaning back against the headrest and closing my eyes.

We drove to a little café with mismatched antique tables, hefty embroidered walls, and the tiny-voiced plucking of Modest Mouse's "The World at Large" wafting out of gaping windows. We collapsed into a corner table like two famished toddlers fresh from a nap. Our expensive eggs and blood-orange iced tea arrived quickly. We disappeared then, to fill our bellies and come back to life. Now we could finally see each other.

"You wanna go to the studio?"

The artist studios at Java Street were in a small-ish building with a center gallery built on creaky floors, surrounded by shabby studios on all sides. The artists who rented space came from all over— more formal backgrounds like Parsons or SVA, or the primarily self-taught at the Art Students League. Unsurprisingly I found myself staring at length at whatever piece Henry was in front of. It had always been clear that Henry was my teacher. He recognized the flicker of light that hit my temples when I fell into a ramble, and he was committed to preserving that light.

After leaving Java, we went to Henry's place. He had been wanting to paint my portrait for a while. I had dismissed him, mostly because I didn't think

he meant it. It was no longer summer—the warm air slipped into a cool evening. I wore a vintage black cashmere sweater with gold neck enclosure and a crushed velvet skirt. My hair was pinned back behind my ears with a burst of curls resting on the top of my head. He painted for several hours while I sat across from him with my ankles crossed, hands resting in my lap. I mostly remember the silence and the quiet thrill in being able to trust someone with that silence.

I recall being confused when I saw the portrait, both with how *he* saw me and how I looked. Henry painted a bold version of me. The portrait was set against a deep cobalt background, my round face and dedicated stare were real and no longer hidden. It was an image that felt true. Which might have been why it upset me so much. I sat for a long while, hands still in lap, suddenly betrayed—a response that could only indicate just how little I had truly seen myself.

Myriad Selves[1]

I could die of difference, or live—myriad selves.
 —Audre Lorde, *The Cancer Journals*

THE ENORMOUS COLLAGE *Jheri Now, Curl Later* by LA-based artist Mark Bradford has been a part of the Brooklyn Museum's permanent collection for over fifteen years. My love affair with Bradford's work began in the year 2004, during an early iteration of the museum's First Saturday program. His palette of peach and silver undertones and tiny square sections of white translucent paper mesmerized me away from my chatty group to stand closer. The sounds of merengue pumped in from the Rodin sculpture gallery as mixed-race children and Black couples milled past me, laughing into the air and one another's faces. A woman, holding an angular plastic cup filled with something bubbly and yellow, stood staring at me for much longer than she took in the artwork. One could only presume that she was considering a flirtatious advance, or was worried about me. Regardless, I was determined to be alone, going so

1. A version of this essay was first published in *Green Mountains Review* in 2018.

far as to close my eyes as I ran my index finger along the roughness of the painting. *Are those endpapers?* I wondered aloud, leaning back to locate the accompanying wall text. Surprised by my accurate instinct, I pressed my fingers along the crisp edges again, disrespecting the art in my rule-breaking worship.

Endpapers were Bradford's meek subject—finishing materials used by Black hairstylists in rollers or pressed onto edges to keep things tight and in line. His work persistently carries such complicated emotional significance, the grid-like pattern conveying the chaotic pace of a city, paired with endpapers from his mother's beauty salon as evidence of his life, all the profound innovation of a Black mind. Decay, essentially. This detail made me think about his mama, his sister, the path that brought this creation to me, to us. As I chuckled thinking about this, I was struck with the feeling that I knew Mark Bradford somehow, and that I wanted to show his art to my father.

Even in my final weeks as a college student, my father still held his dutiful parental post whenever he drove down to visit me—left knee leaning against the driver's side door, key in the ignition, jazz sax tooting out of the speakers. He seemed to be waiting for me my entire life; the car is where we had our most important conversations.

He drove in from our small town in Amish country, Pennsylvania, to spend the weekend with me. Whenever my father came to the city, the first thing

he did was purchase every newspaper. He would get through the dailies—the *New York Post*, the *Daily News*, the *New York Times*—and one weekly, the *Village Voice*, by weekend's end. *It's important to know what everybody is talking about.*

I hustled out after one of my last undergraduate classes to see the gray Volvo double-parked on Second Avenue, near Seventy-Second Street. My curls bounced as I darted across the avenue to get to the car. I had just chopped off all of my hair—the dead, chemically relaxed ends. A decision revealed by the tiny coils mixed with white pillow fuzz sitting atop *his* daughter's head, straight and uneven spurts sparking up all around. When my butt plopped into the passenger seat, his omniscient greeting was immediately paired with a loving and fatherly smile.

"You like it?!" I gushed, anxious for his thoughts on what I'd done to myself.

"You want to be an activist, then girl you need a pick."

A Kool Mild cigarette sat between his left ring and middle fingers, the *New York Post* lay splayed across the steering wheel. It was time for lunch, so I asked him to drive us down to Cafe Orlin in the East Village, one of my favorite places in the city.

"Where is the pharmacy? What's it called, Duane Read-er?"

He tossed his cigarette out the window and turned on the car. He brightened with a new thought spreading across his face and into his eyes.

My father had a way of making me think that he knew more about me than I knew about myself. He carried a startling awareness about the kind of woman I was, some of which made me just like him. *What would you do if a young man proposed to you, girlie?* he would ask, smiling to himself over his own mixed messages. And I, allowing myself to receive this naive role, began to trust that we were the same and that I had been trying to understand my father for my entire life. *Nothing!* I would reply, and we'd giggle together with tears in our eyes. We were both lonely; my mother had only been dead a year. At that time, New York held the least strain for us, fewer memories of my mother, and more places that my father had never experienced. *This is the park where I do my homework*, I would say. Or, *This is my favorite bookstore.*

MY PARENTS, Archie and Willarena, fell in love in the sixties, high school sweethearts, at the apex of the civil rights movement and the war in Vietnam. Concurrently feminists of the second wave sought agency for their bodies and priority for their equally hard yet underpaid work. Malcolm X, Martin Luther King, and Marcus Garvey were all murdered due to government-induced conspiracy. The air was heavy with the desire for humanity; however, seeking this humanity began as a singular struggle. Black men were seen as the leaders of activist groups; white women were at the helm of second wave feminism.

With my sister fastened in a carrier on their chests, my parents would attend sit-ins and Black Panther community meetings between classes and work. Months later, my dad was drafted in the US military to fight in Vietnam. He was given his first pair of glasses at boot camp and would later be booed by anti-war demonstrators while traveling through the Oakland airport in uniform with his comrades.

Archie finished his degree through the GI Bill at Wright State University, and Willa became certified to teach elementary school at Central State University, both schools near their hometown of Dayton, Ohio. They were on their way to achieving a component of the American dream by entering the workforce for the next forty years. My parents dedicated their lives to giving us a good life, at the expense of their actual dreams. My father wanted to become a history teacher, and my mother, an actress and model. Together they wanted a bigger family. Their children would attend decent schools and have all the extracurriculars: ballet class, cheerleading. My sister eventually attended a historically Black college, Morgan State University in Baltimore, Maryland. I landed, unsurprisingly, at a liberal arts college in New York.

Self-expression, I believe, was proudly honored through my parents' sense of style. Archie and Willa were infinitely more well-dressed than their colleagues, a projection of status concurrent with the simultaneous culture of liberation and protection

against racism. My dad had classy combinations of ties with tailored black, gray, or khaki European slacks. My mother wore Liz Claiborne dresses with blazers in cheerful teacher colors like navy blue or yellow. This was a pleasurable armor; it was used to combat the modern oasis of a safe neighborhood and a good education—the Black middle-class family in a small town full of whites. I remember their matching double-breasted khaki trench coats, sported for only a few mild autumn weeks.

Neither of them had a lot of friends in our town. Essentially all they had was each other. My mother's parents died before my sister was born, and my father was raised by his grandparents, eventually raising himself. Maybe this is why they wanted a bigger family—the companionship.

The eighties began and women's studies programs emerged in colleges and universities. The Feminist Press published *All the Women Are White, All the Blacks Are Men, But Some of Us Are Brave*, a testimonial offering the concerns of women of color excluded and ignored from the second wave. Black feminists were rising up around the same time as my mother educated the children of KKK members. To consider whether my mother was feminist feels inadequate. It's hard to not see every part of her life as a sacrifice with little time to consider any other name. For Willa to "have it all," she required the time *and* energy to passionately pontificate about empowerment. Her diary shares of the everyday needs of women who

thrive without labels. She wanted *more romance from her husband* and also wanted *her family to be happy all the time*. Her daughters would become the kind of women who overly considered these matters, rolling around in the privilege of time.

MY DAD AND I sat at a center table in Cafe Orlin, underneath the peeling white columns and surrounded by the heavy-footed waitstaff. I watched as he uncrossed and shifted his creased pant legs, resting his shiny black work shoes on the creaky wooden floor under the table. Freelancers nursed stained cups of coffee or snickered into their books. Small groups ate almost wildly, their silverware clanging against plates and glasses. My father hummed along to Billie Holiday's blues, tempering our mood, as I scribbled in my notebook.

"After lunch, we'll go to the Brooklyn Museum."

"There is a museum in Brooklyn?" The words fell from his lips in a drawn-out melody. Carefully sung, and most certainly planned. I spoke back, my mind darting from wall to wall.

"Daddy, there's a lot of stuff in Brooklyn."

Yellow squash soup in white ceramic bowls was placed between us. The green chives scattered across the surface enhanced the soup's golden color. He grinned at me and carefully ladled a spoonful to his mouth, the soup animating his glasses like the patch of spring dandelions in our Pennsylvania backyard.

"Baby, this soup is so *bright*; I don't think I have ever seen anything like this before."

The soup was "bright" that day, new for my father. I hoped that this discovery would remain somewhere in the middle, where answers were unnecessary.

"Yes, it is, Daddy," I said, finally tasting the soup. "And sweet."

"Yes, very sweet."

I paused. "There is someone that I would like for you to meet too."

"Oh," he replied, without looking up. "Let's see, I have met Lauren and Gloria."

"Yes."

"And Rita, your new roommate. Who else?"

"You'll see."

In the year after my mother's death, my father and I shared more meals together than we had throughout my entire childhood. When I was growing up, we usually hit the kitchen in single file, piling our plates high with defrosted turnip greens and Salisbury steak or sweet spaghetti sauce accompanied by buttery green peas. If grief were generic, one would say that we were in the early stages, a collage of lovingly obsessive attentiveness, mimed interactions, and stultifying forgetfulness. We couldn't handle the harder memories yet, and we didn't find it critical to our conversations over squash soup at Cafe Orlin or even over scallops at Ocean Grill on the Upper West Side. In those days, grieving was as routine as Sunday dinner, mostly because neither of us had to

be alone while pretending. There was an air of break time to these meals and museum visits. *Something is missing*, my mother's diary explained.

Lauren and Gloria joined us at the museum. Like me, they were babies growing up in New York City just after the millennium. That was the year that Gloria had her box braids redone four times in six months. She wore Seven7 brand jeans and would make conversation with my dad about current events, peer to peer.

"Mr. Cardwell, can you believe the subway fare went up, again?!"

Lauren was coy, with alabaster skin and green eyes. Her waist-length honey-colored hair made other white girls call her "earthy," but we considered her educated and unique. The bamba echoing through the museum swelled into a loud thumping, and the small talk dissolved. The marble rotunda recognized this shift and lowered its lights. Gloria smiled to herself and committed to the natural way her hips responded, her head tossing from side to side in slinky and confident movements. Lauren always found herself with a similarly confident but more energized and athletic wind, her core intact, eyes fixed on whoever was watching. I loved to dance but became goofy in front of my father. Before I could feel this, my father started to dance. It began with his feet pointing in and then out, as if they were surprised to be moving. Then his left hand met his hip in an old soul gyration, top lip covering the

bottom with concentration. I watched them all as splinters gathered inside of my chest, the anguish pulling my face into a scowl. As a child, my mother called this expression "mannish," which, for her, was another word for "hateful." But this feeling was new. Envy? I backed away from them.

"I want to show you something." I spoke with premonition. My father moved his hips precariously and slid backward across the marble floor. Lauren and Gloria crumbled into giggles, following him to the center of the dance floor. I watched his eyes scan the crowd with the exotic gaze of a visitor. He saw something. So did I. My father was a man, a person, someone who might not be as sad as me. I pushed past them, reaching into the air to tug at his sleeve, to ask him, suddenly now in my younger voice, to come with me.

"What's the matter, Erica? I'm having fun!" he replied with agitation, turning away from me. When my mother came to New York, she would say similar things. *Let me have fun, baby*, making me feel like I was in the way, uptight, with too many feelings. I have always been an emotional tincture. Conflict boils in my gut, rises to my head before drops of clarity are produced. Too late.

When we made it to the painting, I immediately wanted the paper in my hands. In my father's hands. Or for it to fall at our feet, disturbed and shaken loose, affecting us.

"They are endpapers, Daddy."

"Baby, I would have never thought they could be in a painting." He was sipping water now; small drops hung from his whiskers and mustache. He smiled and tiptoed away, back toward the dance floor. I stayed behind.

I'M UNSURE IF it was the five years since her passing, or the fact that I was aging, that caused the evolution of the city to hit me so hard. By 2008, my generation of youthful transplants were becoming adults, timed distinctly with the steady rise of rent in the city. There were still many ways to see free fine art, like First Saturdays. And I found Mark Bradford's work at a gallery in Chelsea. I teetered across Twenty-Third Street, past the vagrant elders of the Hotel Chelsea, the toxically overshined apples and tomatoes of the Garden of Eden health-food store, making long strides to beat the light on Eighth Avenue. My hair was long enough to be tucked behind my ears if I fancied that, but most of the time it stuck up straight, the frizzy ends now flopping unevenly all over my head. My posture was stronger; gangly legs jutted out like chestnut branches from underneath my mended black-and-white secondhand dress. *Time Out* magazine was folded inside my bag; it listed Bradford's latest exhibit, *Nobody Jones*, at Sikkema Jenkins & Co. The crosstown bus whizzed past me; I was irritated with myself for being too impatient to wait several avenues back. One could easily glide from the white people in Burberry trenches brunching on

Sixth, Seventh, and Eighth Avenues, before passing the Black and Brown children drinking quarter sodas from the bodega on Ninth, on their way to the art world on Tenth Avenue. For a year and a half, I worked in the neighborhood, often confused by the crossroads of class within the community and my own life. It would take me two to three weeks at a time to budget for brunch with my friends in places like Chelsea. Mark Bradford didn't have a solo show until his forties. Before that, he made art on nights and weekends while working in his mother's salon and completing art school in Los Angeles. I waved at the children I knew as I walked by, wondering dryly if any of them knew that they were already artists.

Galleries in Chelsea are often stark white, typical of most expensive art spaces: a blank and flaccid palette for new work, a bit of an airy, echoing emptiness. The Sikkema Jenkins gallery felt moderately like this, but I didn't feel as unwelcome as I was expected, with my used dress, unkempt spray of hair, and ashy ankles. This could have been because the artists on display looked like me. I would later learn of the gallery's priority for featuring contemporary Black artists. I would come to know this when I traced Kara Walker back to its four walls.

And there was something altogether different about Bradford's newer work. The declaration of Blackness through the use of endpapers had now evolved into a more blatant political statement. Bradford's LA held imprints of basketballs—commentary

on the contradiction between capital and poverty in the city. The layers were now symmetrical, a tedious tactic calling forth the fine-tuning of a pastry chef methodically handling stacks of crepes meant to disintegrate in our mouths. Along with Bradford's vision, my perspective had sharpened; I believed myself to be older. Which leaves me to wonder now if the nuanced quality to Bradford's paintings had shifted, or if this was a moment where my Black imagination became more fully realized.

Instead of making art that reflected or mimicked Los Angeles, Bradford's pieces *used* the city, by way of old concert posters and found scraps. In wads and chunks, the city's skin became Bradford's new material—shedding, peeling, disregarded matter. He and his team soaked these materials, then pushed forward with the laborious layering technique his work is famous for. It had been a while since I'd seen Bradford's work in person, despite the boom and zoom of his career's rise. And although he never left my purview, I had become less fixated. This was a period where I needed to stand very still in the same position, in the same spot, without looking around. My grief process had distilled into new, perhaps more interesting, fixations. I was changing and my predilection for visual art remained, but now my means of identifying—by that I mean who I believed myself to be—felt more urgent and demanding of my attention. Love—the task, the issue, the softness—preoccupied my mind at an unrelenting clip. Suddenly, like a lid

loosened by an emerging overflow, I craved romance. If I wasn't alone, I was staring into the eyes of a repetitive betrayal, a woman who wasn't looking back.

Bradford defines his perspective as "social abstraction."[2] This may be the only time that I will hasten to describe a body of work, or someone's life, with the phrase "coming out." It is nothing other than a comment on the evolution of a Black artist—the more exposed we are, the more interested we become in sharing ourselves and being open about the role of art in our lives as it relates to our decay. What part of us is dying as the rest of us continues to live and regenerate? Bradford has revealed what we thought we knew. The memories, just like the endpapers, were only just that—paper.

"SHE BROKE MY heart," I cried into my father's ear over the phone.

I wonder if I would have ever revealed my desire to my father had this woman's rejection not hurt so badly. It all came pouring out, no matter what I would have otherwise preferred. This was certainly a moment where desire inevitably flung itself into high relief.

"Come home, baby," he said.

After what seemed like days riding the train, my eyes beheld the bold healing of the sun's light as

2. Calvin Tomkins, "What Else Can Art Do?," *The New Yorker*, June 15, 2015, https://www.newyorker.com/magazine/2015/06/22/what-else-can-art-do.

it tucked itself away for evening. I was on my way home. But the knot lodged in my throat reminded me that where I was going had never been my home. The older I became, the more leaving New York felt impolite, like a betrayal. It was as if I was walking backward after arriving at my apartment's landing, back down the stairs, onto the concrete sidewalk, and along the eight blocks to the train. There's the meat market with the frozen carcasses in the window. There's the bakery where the cashier accused me of using a stolen debit card. Back to the subway stairs where I didn't intend to hold on to the railing.

The Harrisburg train station was small and old-fashioned. It was protected by a cement arch-way and had only three tracks; only three trains could arrive or depart at a time. My seat on the train was frozen from the air-conditioning; the icy privacy was preferred. I used my sleeve to wipe my face, anxious to think that my father might look at me differently and that I would look different to him. Would he still know me? Or had he known all along? However tragic or amusing it can be to recall our previous selves, there is never one defining moment where one "comes out" in a tangled wrung-out story shared with generations at bended knee. Rather, our stories are more keenly attuned signposts, marking out steps. Desire—whether through art, another body, or acceptance—is desire. It is the tender belly button from which we all undeniably sprang, in all its absence and enthusiastic humiliation. We will

always be left with ourselves. And perhaps the art we choose to make.

When we arrived at his house, I noticed the silk robe in my father's bathroom. There was no floral or abstract design; this robe was unlike my mother's style. She wore pastels of pistachio or rose, some with cigarette burns tarnishing the sleeves. This robe was a bold fuchsia; I was unsure about how long it had been there. And my father had been visiting me less. I would come home, and we'd sit quietly in separate rooms, eating takeout and watching television alone, the way we used to when my mother was alive, comforted by familiarity, gradually losing interest in our New York City dinner-date charade. But it wasn't until I was staring at that silk robe that all of the sorrowful routine began to fall back. Not away, somewhere else.

TWO BEERS, mostly copper and foam, sat between us. Wailing alternative rock croaked through the speakers. Neither of us knew the words. The waitress plopped tin plates on the table; heaping discs of spongey brioche bounced atop thick clusters of beef. We both ordered our burgers the same way: medium well with lettuce, tomato, mayo, and onions. Cheddar for him, Monterey Jack for me. My cheeks puffed out from a healthy first bite. While he chewed, my father's gray hairs pulsed at his temples. We ate quietly. The newspapers were in the car. By now, the gaps in conversation had grown.

"I see what kind of woman you are becoming."

A "mannish" woman, I immediately thought, confused at who was talking, my father or my mother. My full mouth opened, allowing breath to escape in a subtle sigh. We'd never spoken about this. Years before when I landed in front of him, warm with tears over a woman, he hadn't brought it up. He just picked up my bag and drove us home. The fields were mostly weeds that time of year, so we both sneezed and let our itchy eyes excuse away the gaping topic we were avoiding.

"And no man is going to pay your way. I mean, be around to help you. Well, of course *I* will. But I think you are more focused on your . . . well, your career."

"Yes, Daddy."

My hair brushed my shoulders now, with one thin, wiry lock trailing onto my shoulder and down the center of my back. I didn't want to speak too much for fear of interrupting our connection. We hold our breath for moments like this, ones we can savor and recount when we cannot sleep. Especially when these moments do more to enlighten instead of align with what we perceive as hope. I could have wanted my father to say "You desire women and I receive you," or some other trite response inside his full-hearted commitment. This moment was an acknowledgment of his daughter becoming something else.

"I just want to let you know that I've noticed a change."

The France Diaries, Part 1

LONG STALKS of corn flung hard against my legs as I biked down the stone path back to La Forge, a small house at Cat'art, or Centre d'Art Contemporain, an artist's residency near Carcassone. It was 2007, my first summer in France, the first time I managed to leave New York without feeling guilty. It had been seven years since I moved to the city, and a sense of dissatisfaction consumed me. I wanted more. Now, this bike and this house would be my routine for several weeks.

I lived in a large two-floor house—The Farm, in English—with a short spiral staircase, two bedrooms, an office, and a small concrete back porch. The other residents were a cadre of artists and poets, writers, and sculptors, looking for a quiet place to work. "Work" meant a lot of things to us all. Many of us claimed escape more than anything else.

In the time before this residency, I had hardly seen myself naked in over a year. I was very good at avoiding the mirror, wiping my face with a washcloth or brushing my teeth while pacing my apartment.

Longer still was my connection with another body. I hadn't let anyone touch me for what was becoming

years. To characterize this period is easy: complete and utter neglect. To claim awareness for my role in this foreclosure would be futile.

I would attribute it to the last man I slept with, who invaded my body, holding me down in a raw contortion of bones and flesh. We met in front of Tribe, a tiny corner bar nightclub that previously flanked the corner of St. Marks and Second Avenue. The spot was known for its crass waitresses who flawlessly mouthed the words to every song while carrying trays above our heads; drinks were delivered with a "Here you go, sweetie" before they disappeared into the sweaty mob of flailing arms and shouted conversations. It was a favorite spot for Nadia and me: we'd usually meet there at midnight with wads of tip money pressed into the bottoms of our purses. Each night the place would fill gradually with bodies, strangers against strangers, until we eventually spilled out onto the sidewalk, like wayward cockles from the after-hours sea. That's where we met two tall, attractive Black men. Almost immediately, my friend got into a debate with one of them about Jean Genet's *The Balcony*, in a bit of foreshadowing for what lay ahead.

AT CAT'ART, I could relish the feeling of being far away. Like a light switch, I was in love with a man and a woman. I was a very young twenty-five and unconcerned with naming my desire. For a brief affair, I disappeared with the man to his flat in Paris,

a memory contained in the tune of PJ Harvey's "This is Love." He was a decade older than me, a Parisian sound designer who spoke very little English. I slept with certainty my first night in his apartment, comfortably easing into my life's fluttering pages. The smell of baguette charring on a gas flame opened my eyes; I scanned the ceiling with the layers of burgundy and cobalt blankets threading my legs. His walls were covered in concert posters from his sound-mixing work, reminders that he had been successful. Rico was his name—a humble artist who ran to my bedside to welcome me to the morning. *With me, you wake with kiss every day.* He was traveling with a folk band, moving between the villages under the Pyrenees. His eyes were a sketch of green and blue, translucent even inside the single-window darkness of his apartment. Rico had no money; he seemed to clear out the remains of his cupboard in loving courtesy of this brief romance.

Upon my arrival, I had caused us significant delays. I didn't have a watch or a cell phone, so when my train pulled into Gare du Nord, I was lost immediately. Despite this, it's a time of my life that I have come to miss. Our plan for my first day was to have breakfast, get dressed, and walk from his apartment in the Ninth to Montmartre, the top of Paris. He sang to himself, delighted to share Paris with his Black American girl, even though I had been to Montmartre with my family many years before. It must have been the language, or my belief in romance, that

convinced me to keep this secret to myself for that afternoon. I would enjoy Montmartre with him as if it were the first time.

The woman I loved would have to wait until morning. Her name was Louise. We were neighbors at Cat'Art. Her work was mixed-media collage: paint, newspaper scraps, fabric. The kind of work that I would make if I wasn't a writer; however, nowadays my wife tells me that I was a visual artist in a previous life. In the days that followed, while Rico was at work, I waited for his phone line to dial up the internet and typed letters to my long-legged Italian who had just returned to her apartment in the East Village. Louise was the first woman for whom I could not hide my love, but this had always been a friendship. A tender thing that I held close and was afraid to mess up. I had been living at the residency for almost a week before Louise arrived. The other residents and I had planned a small gathering at L'ille, the name for the collection of artist houses closest to town. Glasses of delicious vin en vrac were poured, and we stood around chatting and waiting for the new faces. A fair-skinned Italian woman walked in. She had a short haircut with side-swept bangs, a Euro-pixie kind of look, accentuating her high cheekbones. She wore black Nike high-top sneakers, a long black cardigan, and a purple short-sleeved T-shirt. Her jeans were tight and legs slender. When she laughed, it came out with a giggle at first, then with her head thrown back into yelping silent laughter,

her eyes closed and nostrils flared. How does one love someone and want to be someone at the same exact moment? I carefully planned my words before introducing myself. There was something inside of me that she rocked open, a desire to identify. There was freedom and ease in her laughter, in the way she sipped her wine.

Louise and I were neighbors, houses side by side. Cat'Art was an artist residency, a passion project formed by a woman dying of cancer. After her death, her daughters would visit the residency and lovingly tend to her dream. One had a mohawk and could periodically be found in the yard; early weekend mornings we would hear the motor of a lawn mower kick on. The other sister offered to drive us places; she wore long earrings and a sweet, concerned smile. They were often surprised at how we found this place.

The town of Sainte-Colombe was under a kilometer away. There I would stock up on necessities two or three times a week—a dozen eggs, a few chunks of goat cheese (tending to my lactose intolerance even then), some tomatoes, and more baguette. Every other week, all the artists would take a trip to the main grocery store, Intermarché, in Chalabre to pick up special items like yogurt and cereals and have more vegetables to choose from. Visual artists had studios closer to town. Writers worked in their houses. I wrote in a room adjacent to my bedroom undisturbed. The dry summer consisted of this. Of

dill weed and tarragon, dusty doorsteps and overgrown ivy, and no one familiar in sight.

WHEN RICO AND I arrived in Montmartre, all the bistros with the blue-and-white awnings were filled with tourists poring over dictionaries and snapping photos of French people walking down the street. I watched a woman with a ginger-colored bob sit for her portrait, two Eiffel Tower keychains dangling from her purse. My sister had sat for a similar portrait almost a decade before. Recalling this made me laugh loudly into Rico's ear, unable to explain.

Back home, blushing heat tickled my ears every time I spoke of him. The giddy expression on my face provoked my father to comment, *He seems very special to you.* But this thing happened that I still find hard to explain. Rico and I lost contact once I returned to New York. This could certainly be expected given our six-thousand-kilometer distance and my mere twenty-five years, but it was nevertheless confusing to me because this love felt important. This was a curious revelation, as my days became more dedicated to my friendship with Louise. The morning when I left Rico, my wet face and trembling hands must have appeared comical to my Catalonian bus driver. He stared at me weeping in Rico's arms, chestnut eyes nudging me onto the bus with excessive paternity, saying, *carry on.*

I RECALL A photograph of my mother posed next to the gendarmerie at Notre Dame, lips painted with champagne-colored Fashion Fair lipstick, grinning coyly, an officer on either side. She wore her denim jacket, a sunshine-yellow shirt, and a signature scarf tied around her neck. Her jeans were creased; she'd ironed them in the hotel that morning. I always feel prickly when I see this photograph, like the remains of a fire.

In the years following her death, she would announce herself on quiet nights when the air outside was calm and I still smoked in my bedroom. On those nights the air inside wouldn't stop moving. It had an odd choppiness, whipping around corners when no one else was home. At one point, my bedroom door charged open then immediately slammed itself shut, bouncing and rattling inside the doorframe. This call for my attention continued until I finally stood and responded.

"Okay, Mama. You're going to break the door. I am paying attention."

I wedged a boot between the door and the frame. The lock was now broken. The phone rang.

"You need to go to France. Mom would want you to go to France."

The voice on the other end, also roused in the windy darkness, seemed to speak on behalf of my mother, determined to parent from her grave.

"Mom would want you to go."

I didn't move, mirroring the stillness in the air outside. I didn't want to give away too much; this message had more information. I sipped a long drag from my cigarette, and with my head turned away from the receiver, I released the smoke toward the ceiling, watching it waft along the wall that displayed the caking of a water stain.

"I'll let you know when I am leaving."

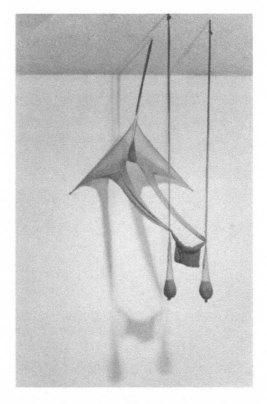

Senga Nengudi, *Swing Low*, 1977. From *Dialectics of Isolation:
An Exhibition of Third World Women Artists in the United States*,
1980, A.I.R. Gallery, Brooklyn, NY, Exhibition Catalog.
A.I.R. Gallery Archives, Fales Library and Special Collections, New York
University, New York, NY. Courtesy of A.I.R Gallery.

Kara Walker and the Black Imagination[1]

An artist grows up in public.
 —Hilton Als

December 2022

I return to this text while drinking from a white ceramic mug with the quote "Art has no sex, but artists do" written in red typewriter font along the front. It's a silly, certainly meta gesture to expose my context—Lucy Lippard quote on a mug filled to the brim with black coffee—before engaging in this bold act of self-study, critiquing myself at the same desk at which I first wrote this essay, the desk that appeared after I asked for it. But this is a meta-activity, isn't it? In Lippard's Distinguished Critic Lecture for the International Association of Art Critics, titled "Changing: On Not Being an Art 'Critic,'" she references the quote: "We were still using the word 'sex' for gender, which made that quotation pretty hilarious."[2]

1. A version of this essay was originally published in *The Believer* in December 2017.
2. Lucy Lippard, "Changing: On Not Being an Art 'Critic,'" AICA-USA Distinguished Critic Lecture, The New School, October 30, 2013, https://www.veralistcenter.org/events/lucy-lippard-changing-on-not-being-an-art-critic.

A punchline still saucy and resonant, even as things require a new way of looking.

To be a subject, to be looked upon.

"How does form make meaning?"[3] A question posed by art critic and scholar Sylvan Barnet is, for some, the fundamental work of the critic, as outlined. The mandate: to analyze the constructed object in relationship to the other elements of the work. And, to disrupt bias, we must get good at looking. And *look*.

Barnet concludes, "If the elements 'cohere' the work is 'meaningful.'"[4] I find coherence to be where this logic falls away, like the few granules of coconut sugar slowly disintegrating at the bottom of my mug.

My return to this essay is an engagement with an archive of self and body, of consciousness and something else. Something without a name. Often, when visiting institutional archives researching Black artists, I find the material that I am requesting easy to access because it is rarely requested. Black male writers are often the easiest to locate— David Driskell, Alain Locke, etc.—but the women require a bit more detective work. While conducting research at the Schomburg Center for Research in Black Culture, I found myself tiptoeing through Lorraine Hansberry's appointment book. Small

3. Sylvan Barnet, *A Short Guide to Writing about Art*, 8th ed. (New York: Pearson, 2005).
4. Barnet, *A Short Guide to Writing about Art*.

diaristic wanderings decorate the margins. *Dinner with James Baldwin, coffee with Oscar Wilde.* Here, we are in abundance. I want more of us to read these dispatches.

I seem to be seeking the tender place. The not-quite-hidden, uninscribed with meaning. Or relationship?

To be Black is quite often to be a constructed object. Suggesting that I am not the subject rejects that the art affects. Stating that art isn't meant to *do* or *be* anything suggests that looking at art is a neutral encounter. Looking at art has never been a neutral encounter. Living within a body unable to detach from persistent objectification, a Black woman knows she needn't only look out for the white gaze.

Rather than parse out the politics of art making as a Black artist, we could critique within the world of our incredible context. This might be more of what Langston Hughes was insisting on for Countee Cullen in his scolding essay "The Negro Artist and the Racial Mountain," in which Hughes admonishes Cullen for wanting to simply identify as an artist and not a Negro artist. That, if not political, the job of the Black artist isn't a neutral one. That there is an inherent simultaneity as artist and critic, with little acknowledgment of these faculties. Is it too complex for anyone other than us? Is this kitchen talk, a place beyond the binary of artist and critic, where our imagination architects a private discourse?

December 2017

Growing up, I didn't have many close Black friends in our rural town, and neither did my parents. I can remember my mother's long-distance phone calls with her best friends in Dayton and Las Vegas that would last an entire weekend afternoon. On many occasions, I walked into my mother's bedroom to find her sitting with hands clasped, tearfully waiting for the phone to ring. When we finally found another Black middle-class family, my father, sister, and I shared a relieved thrill and made plans with them for just about every weekend. This family gave off a worldly scent of sophistication with their larger house and fancy spreads of food and wine. They had a daughter around my age; our mothers immediately threw us in a room together in an aggressive "make friends" gesture of solidarity.

The family held an impressive collection of Black Americana. When they hosted parties, groups of mostly white people would sip cordials and snicker affectionately with one another, surrounded by watermelon figurines and prints of dumbfounded-looking Black babies with sagging diapers. The images made my mother uncomfortable, and she refused to have them in our home. But as my mother became closer with the matriarch of this household, some of the objects began to arrive in our home as gifts. She gave my mother six of the dolls as collector's items. My

mother kept them in the den, an area not often frequented by guests. A collection of six dolls is considered a family; they come in various sizes. According to a 1987 article from the *New York Times*, a "family" of six dolls could be sold for $2,500.[5] The dolls all wear either blue or brown dresses, some checkered or with small flowers. Each of the dolls has a "shoe-black" face with a red thread or a small piece of red fabric for lips, and blue-black yarn for hair, cut short and fraying. They all wear white aprons.

After my mother died, my father drove the dolls up to join me in my exile in the Big City. The dolls' arms and legs flapped on top of her blue ceramic Crock-Pot in the back of the sedan. When they arrived, I didn't know what to do with them. For many years, they lived in a crate in my closet. Once they were finally displayed, I caught myself staring at the dolls frequently, unsure about whether I wanted others to see them. At one point, I even considered giving the dolls individual names. Eventually they folded into the scenery of my apartment—a quotidian namelessness that accomplished the purpose of decoration.

A year later, I had a small party. We had dinner

5. Lena Williams, "Black Memorabilia: The Pride and the Pain," *New York Times*, December 8, 1988, https://www.nytimes.com/1988/12/08/garden/black-memorabilia-the-pride-and-the-pain.html.

of broiled fish and pasta. When we reached the part of the dinner where folks move slowly around to let their food digest, a Black female friend stood in front of the bookshelf and stared at the dolls. From across the room she called out, "Hey, you're not supposed to have these! You're racist!"

FOR NEARLY A decade the artist Kara Walker has placed herself directly in the center of the precarious discourse surrounding Black Americana. The nuance to Walker's own preoccupation with the "act of remembering" and histrionic Blackness is a comment on French and American colonialist art, a renegotiation of objectification found in Black Americana. Walker's memory relies on the information of the past; her famous images—shadows, cutouts, silhouettes depicting explicit sexual and physical Black slave trauma—are positioned to problematize the way we see as Black people, and how we are seen.

While many Black figure painters such as Mickalene Thomas, Kerry James Marshall, and Kehinde Wiley attempt to interrupt history by unseating whiteness from classical landscape and portraiture, Walker chooses to participate in the current narrative by focusing on what hasn't ceased to infiltrate our minds. In a profile of the artist featured in *New York Magazine*, Doreen St. Félix states that Walker is fascinated with "how

to guide the problem of how people look."[6] The article summons a line from Walker's early days as an art star, nearly twenty years ago.

There was fascinating collision with Walker. A simultaneous engagement with the audience and a complete refusal. There was a motion for white people to look closely, *look at what you did.* But I found persistently that many Black women looking at the work were rattled by the brutal imagery of rape scenes and our exaggerated features.

"I think really the whole problem with racism and its continuing legacy in this country is that we simply love it. Who would we be without the 'struggle'?"[7]

Walker's stance has opened her to a lot of controversy. She's been supported by Henry Louis Gates Jr., but women from the Black Arts Movement such as Betye Saar and Howardena Pindell have publicly denounced Walker. Pindell went so far as to anthologize a collection of essays deconstructing Walker, entitled *Kara Walker No / Kara Walker Yes / Kara Walker ?*

The Sikkema Jenkins gallery prioritizes African American contemporary art and has represented Walker since 1995. While her work is being handled with sensitivity, it is also conceivable that it is being viewed by and sold to people

6. Doreen St. Félix, "Kara Walker's Next Act," Vulture, April 17, 2017, https://www.vulture.com/2017/04/kara-walker-after-a-subtlety.html.
7. St. Félix, "Kara Walker's Next Act."

who "don't know what they have." Throughout Walker's career, I have found myself confused about my own discomfort, because no matter how prescient, these images are primarily unintended for me.

The first time I heard Walker's name was in a 1999 review of Suzan-Lori Parks's play *In the Blood* written by Walker's cousin James Hannaham. I was in New York for a summer acting program and religiously snatched up a copy of the *Village Voice* every Wednesday. The entire issue lay spread across mangled flowery bedsheets in my small dorm on Twenty-Third Street and Lexington Avenue. At that time, the *Village Voice*'s critical references were often above my head, laden in nuances of being a New Yorker, but I was attracted to the punchy and opinionated prose of Black people writing about Black art. Hannaham described Parks and Walker to be among an unofficial cohort he called the New Negroes, "who flip stereotypes into tragicomic jokes about oppression and/or slavery, ironically claiming and rewiring all those ridiculous yet pervasive myths about Black people."[8] It was a handful of years later that I saw her work in person. I dragged my twenty-year-old self across the sterility of Madison and Park Avenues to encounter Walker's work at the Guggenheim Museum.

8. James Hannaham, "Funnyhouse of a Negro," *Village Voice*, November 2, 1999, https://www.villagevoice.com/funnyhouse-of-a-negro/.

December 2022

Part of the fun in reading criticism is dipping into someone else's perspective, momentarily. There is a departure, for one thing. A way to slide inside of a gaze rather than consider how you are being viewed. Similarly, when I decided to share my love for women with the rest of the world, it provoked an emotional nakedness that I hadn't prepared myself for. The freer I felt the more I felt observed. Was I imagining this?

December 2017

The exhibition *Insurrection! (Our Tools Were Rudimentary, Yet We Pressed On)* was featured in the spring of 2002. Walker's shiny black silhouettes lay smooth and present against the stark white walls. Initially, each image could be approached with a familiar, almost interpersonal nature. I wanted to touch them; instead, my fingers were splayed and stretched inside of my pocket. Quite simultaneously, the viewer was accosted by an aggressive twist: White men raping Black women and children; Black children defending themselves against violence with swords, scythes, farming hoes. I couldn't take my eyes off the women and children. My feet were locked in place. I was briefly convinced that I'd fabricated these horrors and shamefully looked from side to side, as if I were the culprit. No matter how plainly depicted, the difference

in what I was supposed to see and what I had seen left me disoriented. Black folks around me began to shake their heads. Some backed away; others leaned in closer. It was confusing that the violence had been difficult to discern, at first. The truth was confined to the impression of the silhouettes. And it was hard to understand who was being represented. The experience undermined what I thought was an advanced relationship to art, and my body. Instead of considering myself an amateur in both regards, I committed, with fascination and contempt, to following Walker's work ever since.

IT WAS THROUGH my mother's eyes that I first understood myself to be beautiful. I can recall her staring at my fluttering lashes and lanky arms on Sunday afternoons. Sundays were when the kitchen became her office. After leaning over a pot of collard greens, she'd take a seat to face her houseplants. Even though I knew that she was preparing her lesson plans, I would slide in to inhale the smells and witness her at work. Her fingers were firmly wrapped around a No. 2 pencil, knuckles wrinkled. Next to her, a True Menthol cigarette burned, its smoke dipping and diving along the edge of her face, reaching above her head. I was all mouth and eyes by then, looming around in untied pointe shoes. I would pause and stare blankly into the smoky, salty air.

"You're so pretty, baby," she said. "Those big doe eyes."

No matter how hard I tried to pretend that it hadn't happened, that she had not died—or lived for that matter—the past cast a gradual shadow. Age has made me softer, somewhat rounder. Grief has drawn my pink lips down along the edges. My bottom lip is stained now from a mixture of beauty marks and dark cigarette spots embedded after fourteen years. I have taken to dipping my head or looking around in order to make my inter-locuters move away from looking at my mouth.

Since my mother was also a smoker, I locate her weariness inside the circles under my eyes— as inheritance and as habit. At the end of a school day, it was her routine to light a cigarette as she merged onto the highway exit on her way home. Her students or colleagues could never know she smoked. I prioritized a similar pride-ful boundary. Years ago, a student announced in a brusque, matter-of-fact tone, "Y'all didn't know she smoked. Look at her lips!" My sense of humor is not lost; his comment begged for me to lighten up. The shame from the faded smoker's stain nestled at the center of my bottom lip is grief's self-consciousness.

There were many years that I tried to fix this. My nightstand was a crowded pharmacy of reme-dies: moisturizers, Vaseline, skier's balm, shea butter, cocoa butter, tea tree oil, aloe, homemade

salves. Cigarettes. There were several months where I foolishly smeared Aquaphor on my lips every night as a "treatment" to restore the smoothness that my mother once admired. By morning, my mouth would be swollen and gleaming, exaggerated and unlike me—an object, performing.

December 2022

Criticism as an intimacy experiment. In her essay "Ways of Averting One's Gaze," Adrian Piper defines the art of naming this "self-conscious scrutiny" as a means of confronting cultural racism.[9] Walker's work makes a spectacle of the white gaze. I am not her audience. As I watch from my post of retreat, I begin to wonder why I was still hiding, locked within the tension between aversion and opposition.

To watch. To pay attention, to look back.

Did I succeed by wielding my self-study as an act of resistance against the flagrant everydayness of racist surveillance? Is writing criticism a Black woman's method for interfering in this?

Christina Sharpe refers to this as being "structured by a past that is not yet past" in her chapter "Kara Walker's Monstrous Intimacies."[10] Monstrous intimacies involve faint tensions, corporeal entanglements, invisible regard. The yearning for dialogue

9. Adrian Piper, *Out of Order, Out of Sight: Selected Writings in Art Criticism 1967–1992* (Cambridge, MA: MIT Press, 1999).
10. Christina Sharpe, *Monstrous Intimacies: Making Post-Slavery Subjects* (Durham: Duke University Press, 2010).

stifled me. Traditional definitions of art history might suggest that, as a critic, I should be allergic to the avant-garde and conceptual impressions. That opacity imbues a relationship to distance that I am not sophisticated enough for. A Black woman's experience with an image could provoke anything less than *feeling*.

I had reached a threshold. I am not just a critic, but a Black woman critic.

Count me as *there but not there*.

December 2017

It would be a stretch to say that I "met" Kara Walker. We encountered one another at the opening night for her students' exhibition at the Zimmerli Art Museum in New Brunswick. A handful of her more recent monographs were also on display. My lips were painted burgundy; sweat clung to my neck under my black cotton layers in the surprising April heat wave. I planted myself in front of one of Walker's recent monographs. She was standing there, too, her even skin brightened to copper under the gallery lighting. Swiftly, I analyzed her new haircut—a coiled flash of gray and black sitting atop her head, sides completely shaved—a day-night contrast to the thick halo of chestnut framing her face on the traffic-stopping cover of *New York Magazine* that same week.

A small crowd had gathered—one white man, wearing a baseball cap, baggy jeans, and jacket, discussed his long career working with silhouettes. He had his smartphone out and was scrolling through photographs of his own work. Kara stared at his phone with intent, then graciously slid back into her dimly lit post near some of her recent monographs.

When Kara Walker clapped eyes on me, immediately her gaze seemed to dip down to my mouth. She looked right at my lips, the way people often do. There wasn't a boldness or rudeness to it, but she prodded at her own bottom lip, and I felt subject to a fixation that often triggers a certain mania in me. Most of the time, my mouth feels like a laborious appendage, something that I tend to think about excessively, to the point of overt concern. Emotional conjecture wills it so, constructing a scenario unrelated to the actual experience. When people stare at my lips, the feeling is what I would imagine someone with large breasts is burdened with in casual inter-actions. *Look into my eyes.* This gaze is blatant and disruptive, an indication of whether someone is actually listening. It also indicates someone's relationship to themselves, to their insecurity, the level at which they have been racialized. *Look into my eyes.* This dependable mania of admira-tion and objectification is the kind of thing that

some Black women experience with their hair or skin tone. *Look into my eyes.* This, undoubtedly, is where my Black imagination wanes. This is where Black trauma lives, drenched in the mania that our imagination and our pain drink from the same cup. "Mania" is the word—the skill—when nearly every social scenario feels deeply personal, like an attack. I wonder how many Black women could relate to this level of defense. And I wonder, too, if Kara can relate to this experience, and the psychology thereof, because Kara did meet my eyes.

"Who is this?" I mustered.

We spoke in front of a portrait—a cutout profile of a Black woman wearing a white mask over her eyes and mouth, with a bee in front of her nose. The visible breast of the figure was small and the bee was a speck-sized scribble, the bee's agitation just subtle enough to connect to the viewer. The image relayed privacy, a sense of quiet. There was consciousness; there was also no esteem. We could see her; her eyes were covered.

"Oh, I don't know," she replied, smiling. "This is a figure that I'd been wanting to draw for a while."

In the image, one could pause at the bee and take notice of the sound immediately emergent.

Walker wanted to be sure to scrutinize how it was received and sent a camera crew to film the crowds as they preened, laughed, and selfied around her—producing a kind of surveillance footage. Then she screened the result at Sikkema Jenkins, the gallery that has represented her since 1995.

—Doreen St. Félix[11]

A BLACK WOMAN named Ruth stood next to me at the summer exhibition of *A Subtlety*, Walker's gargantuan sugar sculpture of Mammy as sphinx at the Domino Sugar Factory. The presence of white people taking selfies next to the sculpture's upturned labia was zapping my energy. I needed to sit down. Ruth joined me on the bench, gazing at me with expectation.

"Hi there. Isn't it amazing?"

Her natural hair was wrapped in a French twist, flanking her temples in waves. She gave me a gentle smile, full lashes curled against her lids.

"That's one way to put it." In the face of Ruth's pleasure, my logic demanded answers. This was a reaction that Walker had facilitated and not created, a reaction that once again whirled me into conflict.

"Why is she doing this to us?" I asked, spilling my vulnerability all over her.

Ruth smiled. It was the kind of smile that

11. St. Félix, "Kara Walker's Next Act."

— 90 —

causes you to drop your shoulders. Briefly, you consider messengers, and other fondness from your past.

"But look at how big it is!" Ruth replied, awestruck and genuine.

She felt honored by the artist and the exposure the art was getting all over the world. The sculpture's magnificent size was a defining moment for many Black women like her and like me, she said. She and her husband had ridden the subway from Fresh Meadows, Queens, to see this piece. Ruth didn't have an elaborate critique. Mainly, she was fascinated with the audience's exposure to history, precisely the component I was colliding with.

It was easy to consider that something must be off about this woman to allow herself to be blinded by the size of the sphinx, reduced enough to find this work astounding. It was easy to consider that something must be off about me, not allowing myself to acknowledge the size of the sphinx and find this work astounding. I wanted to judge Ruth. But no matter how fraught our exchange, fractured slightly by the inability to relate to one another, we were in dialogue as Black women, and as the outsiders that we were made to be. Such opportunities for dialogue—between sophisticated art goers, appreciative visitors, and offended subjects—may have

offered more reflection for *A Subtlety*. But Walker managed to satisfy her audience, thrusting Black women into high relief, a radical experiment with, in Walker's words, "rudimentary tools." Weeks later, Black artists with the slogan "We Are Here" staged an action to acknowledge the presence of slave ancestors in the space.

At whose expense is a Black person, a Black woman, truly able to critique Blackness? When one feels permanently exiled?

Or is it when a Black woman can truly perceive herself as beautiful? Could I be beautiful? With my broad, dark eyes, seeking to rest on the horizon? Is it the fullness of my round face, which gives me my youthful and concerned profile? Or is it my mouth—soft, pink, and speckled with memory? Could I be beautiful?

My mother wore Fashion Fair lipstick. Her color was Champagne no. 9. She would roll the stick along her lips like ice cream; the tip formed a slick cone shape, a leaner silhouette than a Hershey's Kiss. My lipstick is an over-priced clay color called Tanganyka. I purchased it after asking the salesperson to show me colors that would even out the marks on my lips. I have three tubes of my mother's lipstick, preserved in a makeup bag in the same crate that held the dolls. Recently, I've considered selling my doll collection. In 2017 a family of six Black Americana dolls could get me around $6,000.

December 2022

A friend told me after reading this essay that she thought I didn't want people to look at my face. Her comment electrified me. I am amazed by how much of life is contained in such gestures, the permissions we require, the names, the verbs, the identities I had given away.

When I consider the voice that wrote this text, I find her to be still a part of my body, but like a limb, thorny and overgrown. I no longer need her. I do still find the work to unearth me. Here my own theory of intimacies might have backfired. Surely the solvent wasn't primarily within me; it involved a kind of "genre trouble." *there but not there*

To be *read*. When did we begin to rely on form?

I chew on this as I exit an archive where I have been studying these texts. I move through this as I wash my hands in the bathroom. I consider this as I round the corner, call out "good night" to the coat-check staff but somehow not loudly enough to warrant a response. As I tuck my bike helmet further under my elbow, I notice a Black man rounding the corner ahead of me. He is limping and looks my way. I look his way. Our eyes dart self-consciously. Finally, I decide to smile, to show him that I see him and that I am smiling. He acknowledges this gesture, his lips separate into a soft smile. Generous, somehow. Once I reach my bike, I talk to myself, unwittingly. *Rather than looking closely, why not look around.* I linger within the obviousness of this realization. I let

it loosen the lock of my bicycle, hoist my bag over my shoulder, and nod a brief thank you to a cyclist that lets me pass in front.

The France Diaries, Part 2: Obama Has iPhone

A YEAR BEFORE I left New York for the second time, I directed the play *Sonnets for an Old Century* by José Rivera at the Bank Street Theater. As the story goes for most artists in the city, I was also a waitress. The restaurant was a coffee house chain, patenting the environment of bistro, with broad tables made of repurposed wood holding court in every location. After my shift, I would hustle across town to dress rehearsal. I was steaming soy milk for a pair of lattes as a tourist couple huddled over the *Time Out New York* "weekend picks" section. In two swift moves, I managed to deliver their coffees without spilling a drop, their bill slyly tucked between the oversized bowls. I whispered, "Thank you," but as I slid away, the corner of my eye caught an image from my play. I yelped at first, but quickly held my breath to maintain my cool, instead releasing a sound much like a hiccup. The couple glanced up at me, just as I blurted out, "That's my play."

My life contained a lot of this unexpected symmetry, an affirmation of being right where I was supposed to be, no matter how hard it was.

ON FATHER'S DAY in 2009, I found myself standing in hungry isolation in an old French convent. The space was converted into an artist residence. The kitchen served as a water cooler for our rotating creative class. Pots and people bubbled over with important conversations. Coffee, milk, and any of the dried goods in the back were available for the taking. Much like landing in the middle of a party filled with strangers, the only way to find something substantial to eat was to wade through introductions. A nectarine entered my periphery.

It was my second summer in France, and I was staying at a residency called the Performing Arts Forum, or PAF, in the northernmost region of the country. Two years prior, I was connecting to the internet using a dial-up modem in a one-room apartment in Paris, and now I was grumbling about technology with those who had never seen a smartphone, a time so precious I could cry.

A beguiling Iranian man probed just after I chided him and everyone else for mentioning the device that would come to take over our lives.

"But . . . Obama has an iPhone." I held his gaze and mouthed each syllable into his face taunting him with my brash city-girl candor. "O-BA-MA HAS I-PHONE."

His blinking was slight, protecting moist eyes that refused to be annoyed at my cutting response. The prospect of the first Black president having an iPhone filled him with wonder. The internet has

formed us all into critics and Obama was the first president to rely on the internet as a crucial element of his campaign. "Progressive" was the word for every single aspect of that time—rapid, informed, earnest forward motion. Black Twitter would garner its name as the internet enabled existential resistance as a recourse for our perpetual rejection. Here, we could engage in joyful kitchen talk in this meta-public setting. This wasn't enough of an escape for me, so I chose to run, unoriginally, to where I had been just years prior. Resisting technology wasn't new, and neither was the discourse. What *was* new? The prevailing presence of blue light brightening my friends' faces as they stared into their handheld computers. I coveted my anonymity—which made it easy to believe that the only way to retain privacy would be to forego the convenience and mediated connections my friends were boasting about altogether. If visibility was the priority of the time, then casting the technology aside was easy for me.

The early days of mishaps from the sweaty device-filled palms incurred ridiculous injuries like running into telephone poles or ham-fisted texts to the wrong friend. Calling myself a Luddite at this time was a character description, not yet a flaw, adding humor to my gangly, unrequited frame. Inevitably along with the disavowal of privacy came the barrage of opinions. Pulpits. Soapboxes. Beliefs. The digital era gave a mic to droves of voices who were previously assailed and dismissed. The project of criticism was

no longer questionable or righteous—identity was now an art object, adornment by competing hyphenation that categorized both how we were seen and how we were looking. It was on my return to France that this became undeniable.

THE NEXT DAY, someone pointed out the electric bikes that were shared by all of the artists. I had never used an electric bike before. When I plopped onto the seat, I pedaled forward in my usual way, startled as it propelled me with a subtle jolt. Before I knew it, I was bounding down the hill toward the market at a refreshing speed. The main supermarket, Intermarché, sat beyond the railroad tracks. I was trying to read the contents of a bottle of French shampoo just as the first set of lights flickered off. It was midday and stores were already closing. I could hear coins being counted and voices moving quickly. I hustled to pay and get outside as the women snickered at my poor planning.

And then Jack appeared.

I always liked women that looked like boys. Jack had rolled me a cigarette the night before. We both were hiding in the kitchen; she whispered "bonsoir" to me before slipping out to smoke. Jack was Belgian, with hair that sat in a brown collection of shoulder-length strands. The ruddiness of her face was substantiated by the edgework of her father's jaw. She slammed the trunk of her car closed and lit a cigarette.

"Erica?"

Her voice was soft and authentic.

"Yes!" I flung around, relieved to hear my name. Jack surveyed my overstuffed bags of groceries, taking a long steady drag. She opened the trunk and walked toward me. My arms lifted to greet her, but she walked past me to my groceries.

Jack exhaled. "Okay?"

"Thank you," I said.

Trunk slammed; cigarette flung. For a moment, I considered jumping in the passenger side and ditching my bike altogether for a ride with my rescuer.

"Will you follow me?"

A tidal wave of Peugeots was pulling out of the lot. I stepped back toward the bike, ready to follow the cluster back across the railroad tracks. A fork in the road bumped me past the correct turn, but I kept going. Jack was no longer in front of me. Accustomed to isolation, I chose to push the pedals forward in pursuit of the wrong direction. The bike's electricity persisted, like daylight surmounting the Pyrenees— destined to disappear. But as I entered the rabbit hole, I decided to switch on the lights.

I punched down hard on the brakes and simply turned back.

When I arrived, my nectarines greeted me. They'd been laid out carefully by Frank. The kitchen was in a more constructive state of waking life. Laptops were out; folks chatted person to person. No one had missed me.

ON MY SECOND morning, I slid down to the kitchen, where there was a line in front of the ancient espresso machines. Nathan was dumping beans into the top of a machine. He was a calm and friendly breeze juxtaposed against the precaffein-ated cottonmouths. When it was my turn, I began to press several buttons, hoping even half a shot would appear.

"You do it like this," Nathan said.

He laid a sheepish finger next to mine, pressing a button I hadn't seen. Mahogany-colored life driz-zled into my tiny cup. He looked like he had been up for hours, pressing buttons. My shoulders relented, eyes lifted into my first smile.

"I'm Erica."

The day eased into its familiar hue, displaying a similar rouge to my nectarine. This warmed me as I headed toward the bicycles, sipping my bitter drink.

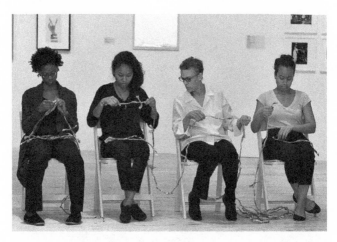

Maren Hassinger, *Women's Work*, 2006/2012. A performance at the
Contemporary Arts Museum Houston, TX, in conjunction with *Radical
Presence: Black Performance in Contemporary Art*. Photo by Adam Avila.
Courtesy of Susan Inglett Gallery, NYC.

The Poetics of Criticism

Only the intuitive is truly unlimited.
—Adrian Piper, *Out of Order, Out of Sight:*
Selected Writings in Art Criticism 1967–1992

THE SIGNATURE PERFORMANCE by Maren Hassinger is called *Women's Work*, which has been featured all over the world. Hassinger along with five participants—typically students or gallery assistants—walk into the room carrying their chairs and a copy of the *New York Times*. Hassinger is seated in the center, usually, and once everyone has taken their seat, they lift the front page of the paper in front of them and begin ripping it into slender stripes. The process immediately calls forth papier-mâché piñatas from childhood, wrapping balloons filled with candy. Each strip is lain across their laps, like a cloth napkin. Those who finish first wait for the others to tear their final strip. Once complete, Hassinger glances to her left and right to ensure they all begin at the same time. They each take two strips and twist them together. Each person uses a different technique. Some appear to start in the middle and work the strand around itself. Others appear to twist

starting at the end, lifting it between their hands and rolling like doughy breadsticks. Once all the tendrils have been formed, they are attached at the end to make a long strand.

Women's Work accesses a familiar register—a knitting circle, bead night, or kitchen table. It is the steady hands at work, the silence, the soft glances and the passes between. The utility is there too. The fiber strands are a direct material concern for Hassinger and frequently appear in her work. Once all of the strands have been connected, they are rolled into a ball before being passed down to combine with the others. Hassinger's paper ball is first, then she hands it down to a participant at the end who finished early. As they wrap, they smush the paper deeper into the ball to avoid loose threads.

This performance displays a version of what writers consider "thinking on the page," an attempt to define the intimate nature of working-it-out-in-front-of-you prose. This is how we are taught to pursue a tonal ease, one that acts as a sensorial magnet for the reader, raising the hairs on their arms as they witness the writer *thinking*. My process of writing about art began with this awakening, showing my work. The sound of soup gurgling nearby. Sunlight peeking through the heavy scrim of a gray afternoon. *I am in the room with you.* Henry believed that if I leaned in close enough to the actual artwork, I could conjure this wisdom. By doing this, I would

not only feel something but also, slowly and fastidiously, *know* something.

This knowingness recalls when I would take to crying in church as a child. There I would be, weeping in my sister's arms. The sight of me would raise eyebrows and invoke more people to slide farther away in the pew with purposefulness. Queer narratives would have one think that this child who was aware of their queer self at a young age, squirming untenably from within, also recognized a need to hide. Crying, potentially, displayed this shame. On the contrary, the tears—the complete and terrifying spill—rattled me with relief. Now, in my adult life, when I don't cry, or when I resist tears, the eruption inside of me manifests in some way. Swollen glands, dry mouth, inflamed gut. Eventually a match is lit inside of me and an unprovoked outburst collides with the ones I love.

I began to chase this knowingness. I believed that being close to the work was one way. I needed the presence of art to invoke an emotive, even osmotic, tickle. Shift my hardwiring, if even for a moment. Visiting a gallery with a friend always proved fun, but I would need to settle myself, the way others composed themselves while they looked. My penchant for leaning in wasn't posh—it was learned and coveted by me. Some would walk by with a polite scan of the work. Others would chat in front of it. I was always the strangest one, leaning close as if to peer inside. Resigned, I often would fall back, relying

on heady conversation or consoling myself in know-ing that I would visit the exhibition a second time. I might be pointing toward a certain kind of learning.

WHAT DOES IT mean to have my mother's diary? I think it begins with what I learned.

When I first decided to write this book, to lean into the divine challenge of putting this into my own words even if I was left with more questions, I knew that I had to contend with my mother's diary. There are usually two places people will land when I disclose my relationship to her sacred text. *How do you feel about this potential invasion of your moth-er's privacy?* And the other question, *Did she write about you?*

I have my mother's diary is how the conversation begins. I used to freely disclose, foiled into regret later, and I would fling this comment out vulnera-bly in the early days of this book project. A writing professor offered this reassurance when I mentioned her diary during a meeting. I was in my mid-thirties, juggling an MFA and a full-time job, which was a grueling tension of differing survivals. I was accus-tomed to warding off the dicey, judgmental stares with quick responses contained in my arsenal: *Her best friend gave it to me.* Or, *She said that I was supposed to have it.* But before I could go there, his response fell effortlessly from his mouth with eyes fixed on mine, bestowing wisdom in the style of a good mentor.

Of course you do.

His comment produced an immediate ease. I dropped my shoulders and stared in his direction, away from his eyes and homing in on a farther space. An opening. Early on, twentysomething and motherless, the diary, like an artifact, had lived in my nightstand, a plastic tub with a scarf laid over the rubber lid—a remnant of college dorm life. I would hold it in my hands for hours sometimes, as a way of connecting with her hands, her mind, her sorrow, her privacy. Reading it was not yet possible. In fact, I hadn't considered it fully. For a while, having it in my possession primarily served to provide me with moments of closeness that I craved. I convinced myself that was enough.

Of course you do.

This statement landed with swift conviction. Faith, even. It reminded me that I was a daughter. Also a child, whose mother had disappeared. Willarena cannot join me in this process in body. Spending time with her diary manages to keep her story alive.

To jump ahead to the book's completion, I found myself at a holiday party chatting about my manuscript. This was almost seven years later, and I was still warmed-over after the death of my father. I had always been resistant to discussing my book with strangers. I presumed they wouldn't understand or the conversation would lead to piles of questions I didn't want to answer. This moment was all of those things, but I had had a few glasses of wine

and was feeling soothed by the intimacy of a small gathering of people near the end of a third year with the pandemic, unmasked, laughing into the air, and reaching for the same handful of crackers. As I began to babble on about the book's conceit, something different occurred. I could feel Virginia Woolf somewhere close by. I decided to speak of her, about how her diaries often documented not her life but her writing, how the ones we also consider diaries, such as *Moments of Being*, with their close talk and humming, may have only displayed the truth she wanted us to know. At least not until she was ready to end her life. She had taught us to write like this. She had asked us to write like this. I have often wondered about Woolf's decision to finally reveal her legacy of trauma a few months before her death, in a book that her sister had told her to write, a task summoning clairvoyance of her kin. Did she know that it was the end?

Neither Woolf nor my mother mastered what we might be discussing here, abandoning the voices in one's head in order to push oneself into private escape. One dares to confide in their diaries, but the blockage often involves judgment we've attempted to escape: *How do I sound? Can I say this out loud?* I started to realize that rather than refute this voice, why not talk back? Is the writer's voice a conversation, in dialogue with another all-consuming self? Maybe this is what Woolf also realized. Maybe she did it because she had always just wanted to be

alone. Alone in a different sense, only attained at the offing. The imagination and its voice, detangling our braids and uncurling our toes. Pressing your pen harder into your notebook cannot extinguish the prying sensibility.

What if we earned this "I" that we use? This lilting reed that continues to show up in our texts, often admonished and overanalyzed. Rarely welcomed. I ask my students to "earn the I" to guide their relationship with a subconscious voice that is begging for their attention. Welcome the critic, the naysayer! Ask them, *What do you want?!* Be in relationship to the voices, the ones that arrive when you are most quiet. Earn the trust, tend to this voice. Tell it, *I'm glad you're here, I'm here too.*

Much like my mother's kitchen, her diary became a ritual. Having it in my possession was evidence of an inheritance, of a lineage and the close talk of her thoughts. It took me a while to read it. I didn't find it to be a text that I wanted to steal away and read privately, no matter how curious I was to know what was inside. I didn't know my mother kept a diary until her friend told me about it. In fact, her friend knew where it was, or knew where to look, despite having never been to our home. Privacy, or the invasion of it, when I think about the choice to write about it, has little to do with disclosure. I have no intention or interest in writing about my mother's personal feelings. I write about her diary to do what Adrienne Rich described in "Diving into the Wreck":

to explore the wreck. To find out what happened. Much of what I would come to learn had little to do with the content of my mother's words and more with *how* she wrote about herself, about us, about her life. Even as a child, I was always interested in my mother as an artist with quite an organic wondering, presumably because I always believed her to be one. My curiosity about her thoughts on me will never go away, even after reading this capsule of her writing. *Of course you do.*

I finally read her diary while attending an artist's residency in Vermont. I had packed it with me because I believed that the time alone in a writing studio would present me with the psychic space— breath between line breaks, the pause before speaking, the blinking of my eyes—to consider my mother's writing.

The residency overlapped with the inauguration of Donald Trump, so all of the artists and writers were on edge. I was one of few Black people in the entire town, let alone at the residency, so processing the violent, xenophobic president who might have been elected by many of the people I was making art alongside was often isolating. This residency had a tradition of a weekly karaoke night. Every time someone brought it up, I would internally denounce my stage fright as an inability to have fun, feeling mostly plagued by the idea of having to get up and sing Whitney Houston outside of my bedroom. Most of the other writers loved karaoke and frequently

participated with their friends. I chose not to disclose my anxiety and instead tried to hide by the bar, shuffling between another round or joining groups of folks singing to keep myself from a solo rendition of "Hit Me Baby One More Time."

One Friday I sat at the bar, bemoaning my writing with another peer. After disappearing between songs for a frigid cigarette outside, I heard my name called in the lineup of upcoming songs—Whitney Houston's "I Want to Dance with Somebody." My heart began to surge through my chest as I quickly scanned the crowd to figure out who was responsible. One of the overzealous and potentially well-meaning writers had signed me up and smiled with a sly, all-knowing grin from the corner. I felt trapped by this initiation— absurdly frantic when faced with the opportunity to have some fun. I found myself overwhelmed by the task of saying yes, activated when I thought about how silly I was being, why was this such a big deal.

As I made my way onstage, the applause shook the entire bar. This lifted me higher, so I sang. *Loud*. As loud as I could. People were howling, bleary eyed in their drunkenness. At a certain point they started singing along because everyone loves this song and how I sounded didn't matter. Then I realized that people were singing along not because I sounded bad but because I was *boring*. They might have assumed that the Black girl would do something phenomenal with this song. Instead, the realization was that Erica was just a nerd whose singing was

mediocre. The crowd eventually turned away with disinterest. The song ended and it was over. I felt relieved but tired at the end of it.

When I returned to my seat at the bar, I felt like I had been through something. I didn't want to be there. I turned to look around and there was no one near me. They were all talking with other people or, it would seem, refusing to speak with me. Their eyes, disinterested in me, looking past my sight line. I had shown too much. Too much skin, not enough fun. And it was clear that no one wanted me to see them.

I threw myself back out into the falling snow and lit a cigarette, lifting my face to each approaching flurry. "What do you want?" I whispered, nearly breathless. Almost immediately I flung my head forward, snuffed out my cigarette, and marched into the storm. Back in my bedroom, layers piled around me, I dug into my suitcase and found my mother's diary. I climbed into bed and propped myself against a pillow and began to read in the lamplight. *I'm glad you're here, I'm here too.*

I am mentioned often in my mother's diary. She rarely traveled without me, but at home we all kept to ourselves, eating meals in separate rooms. *I never knew Erica to be so shy.* Her diary begins with "Great Day" because it was her last day on lithium, a moment I presume to be the turning point in her misdiagnosed mood disorder. The tight, unidentifiable scrawl of the earlier pages returned to the looping and graceful penmanship that I know, the

handwriting that I inherited. She rejoiced the day she was taken off lithium, but she wouldn't be able to write about it for another six months, resuming in June of 1997. It is clear from her future entries that even though her frustrations may have lessened, they never disappeared. *I felt a little anxious and depressed, so I prayed.*

Most of her diary entries begin as prayers, or with "Hi!"—a jubilant vulnerability that I also inherited, that strangers, enemies, and acquaintances make me feel ashamed of. This signals the period in which Xanax and other pills were meant to stabilize and reconfigure her. The presence of prayer in her diary made me curious about the prayers she hadn't written down, like generations of Black women who were raised to believe that life must be lived in a constant state of humility. *Give it to God*, we are told. Her desire for faith only makes the presence of withholding more pronounced, letting the truth lurk in transparent ink in all the blank spaces, requiring a special flashlight for nosy daughters. Willarena writes as a woman, a mother, a person who desired the simple things like a good meal, laughing from the gut, and the essence of romance. *But these negative thoughts are in God's hands and I'm aiming at the maximum level of LOVE, that Jesus gave to everyone.*

Her diary carries the stubborn theme of needing to balance the amount of weakness with the amount of clarity and impressiveness for her audience, revealing a haunting awareness of being watched

by doctors and us, already heightened by living as a Black woman in this world. *It seems that I will never be good enough.* Her entries ask the questions of longing that my Black woman self frequently asks. There are strike-throughs if she used an incorrect word or "it's" instead of "its," implying a schoolteacher, and proper language, such as *my lower bathroom*, *my husband*, as if the person writing didn't know herself. The presence of reassurance is also noticeable. Every single entry seeks relief from her sadness. A Black woman's diary is most certainly a holy space.

"Pleasure" hints, and it appears frequently. But the presence of God is persistent, like a template, with words pressed on the pages ahead of time. *With God there is ____. Faith without ____ is ____.* When I read her diary, the patronizing phrase "rich inner life" bobs around in the front of my mind, a precarious phrase typically used by doctors and social circles when describing a woman, an artist, a person with brown skin, a unique mind, and a very present intuition. *I feel the flow of energy on my body, my thoughts, and actions.* Her inner world is what I seem to be craving, but if I am to continue to read her diary, I will have to accept that my mother was not talking to me.

The act of studying her sacred text revealed how much I wanted my parents to be people other than who they were. *Wanted.* The way one naively wants to fit in like the tallest blade of grass. Or loose granules

of rice that float to the surface when the water first begins to bubble. What I mean to say is that I didn't want to stand out as much as I did. I wanted to be special and ordinary, a conflicting desire. Reflecting on their absence, I cannot deny that being an artist was already chosen for me.

Along with her list of *collard greens, pick up the dry cleaning, take Erica to ballet class*, there was always *sew the pillow* or *reupholster the seat cushion of the phone chair*. Handicraft, or progressively overused words such as "self-care," was my mother's daily practice. There is a loving tradition of Black women who maintained needlework and sewing as a device of self-medication alongside domestic duty, perhaps their quilted version of diaries, inspiration for the artist Faith Ringgold's *Story Quilts*. My mother purchased the phone chair at a place called Clara's Boutique, after an incident with her friend Miss Vivian, a Black general in the US Army and dear friend of our family. Another woman named Lynn, a white woman, walked in. My mother experienced what she describes as *extreme paranoia without an explanation* and was unable to shake it off. *I became very paranoid but after I let it show I realized Jesus is Love*. It is not clear what happened; it doesn't matter. Whatever it was consumed her and she couldn't let it go until she meditated on it in her diary. I find myself facing similar moments. Where the insecurity lurks, ready to strike with a pressing fear when there is no incident to tether these irrational feelings

to. There must be a word for this other than "para-noia." Even as I write this, my head swings into the madness of betrayal of not fitting in. In the very next entry, she returns to the store, I am with her now, and purchases the phone chair, two table lamps, and an antique wingback. We continued with our errands—the grocery store and the post office—purchasing a bookmark and pen for Lynn along the way. The bookmark may have been intended to placate this white woman, but it also served to soothe my moth-er's struggling self, a remedy she called *sisterly love*. Willarena would later upholster the seat cushion for the phone chair in a pink-and-green floral pattern, dark-blue stripes along the edges.

I am often surprised by how incredibly outspo-ken I can be. Surprised enough to struggle with thinking before I open my mouth, an imbalance that appears first in my mind, disrupting a defini-tive "yes" and "no," an up or a down, the difference between a feeling of distress or pleasure. It is this difficulty with balance, with perception, that guided my struggling mother to consider driving to the gas station at night while wearing sunglasses. My wife considers what I believe to be hysterical outbursts as just me at my most proclaimed self. Since the beginning of us, I have marveled at the way she sleeps. Unlike me, her ability to relent into a dormant state is enviable. "Brown-skinned rest" is a naive presumption of mine, recalling the times when a commitment to sleep belied a commitment

to the world. It is a cherished and brief spell she is under, often interrupted by disrupted rest. At times, and with drawn-out hesitance, I'll wake her, grateful that someone who loves me is near enough to bear witness to my body. *Did I sound too ____? Am I ____?* Our differences combine into a tender whispered repose of one body, into space that together we create, briefly away from the world. A dialectical imagination—ruminative when spoken aloud and alongside of you.

My mother writes, *Erica has a hormone problem Lord please help my child to cope.* It was 1997 and I was fifteen years old. My mother doesn't explain the "hormone problem" but there is, finally, a revelation. I want, so badly, to not feel this, but I know my mother would have held disappointment with the queer spirit that would inevitably take over, the actualization of my body. While I know that she would have never stopped loving me, I also know that it would have been a hard thing for her to let go, that I wouldn't be able to emulate the kind of woman she believed herself to be. Would Willarena have been comfortable with calling me an artist; would she have seen me? Did she believe herself to be an artist? I understand tragedy to be more than the incident; it is the unearthing of everything you know to be true. It is having to start over because you are alive and not because you want to live, when the past is fascinating and comfortable enough that you are fine with living inside of it and its words long enough

that the days tumble out into some formation of a life. It seems that I have renamed my mother to make her more like me.

The problem with her new sight was that the snare of anxieties was now visible, like a young animal clearing the brush that had been entangled in its fur only to reveal that they had been inside of a trap all along and the pain they felt had been real. Clearing the brush was a small task inside the rest of the burden.

Aristotle's *Poetics* relies on tragedy as an organizing principle. Tragedy conveys narrative action; the philosopher suggests "embellished language" or rhythmic tone to move the story along. Black feminist poetics has more discursive, ruminative organizing principles, in which intuition, process, and relation are central themes. "Thinking on the page," or perhaps what Tisa Bryant describes as "one tongue with the sound of many eyes."[1] The eye. Or the "I." Might the poetics of criticism be the process of recovering the "I"? One that displays lived experience as form and leans into the scattered nonlinear sensibility.

I consider my writing to take on a mélange of an identity. Words like "scattered" or "all over the place"

1. Tisa Bryant, "'From Our Whole Self': An Intraview of Black Women Writers' Experimentation Essay on Elided African Diasporic Aesthetics in Prose," in *Letters to the Future: Black Women/Radical Writing*, ed. Erica Hunt and Dawn Lundy Martin (Tucson, AZ: Kore Press, 2018), 402–13.

are an easy description, and "hard to follow," which is slapped onto Black abstraction. As the writer Jen Soriano suggests, certain complex thought can only live as hybrid, prismatic perspectives.[2] In fact, much of my writing required a process of unlearning linearity, a fending off that was often a subconscious ploy of foisting traditional narratives upon my prose. My mother's experience as a Black woman, my experience as a Black woman, my experience as a daughter in this world are clear in her sentences, her evolving syntax and taut cursive that reflected the heavy mismedication. I can't help but think that no one was looking at her.

But when did it become about her being an artist?

Before I knew it, I found myself reading the book with the eye of a critic, scanning and studying the text as an art form. This formed my writerly self, more than school or other teachers. The question of formal training for a critic involves more the conversations they've had and their experiences in the world. A catalogue of the body is a suitable index—as repository for the untold is the legacy for the queer and of color. My mother's diary became a foundational text with little choice or realization.

Defining the Black imagination struck first. The shift in consciousness is one of grief's most

2. Jen Soriano, "Multiplicity from the Margins: The Expansive Truth of Intersectional Form," *Assay: A Journal of Nonfiction Studies* (fall 2018), https://www.assayjournal.com/jen-soriano-multiplicity-from-the-margins-the-expansive-truth-of-intersectional-form-51.html.

precarious details. This world was at its loudest and clearest tone in the presence of art. This distinction is unwavering—"in the presence of." I do find my Black imagination to exist "in the presence of." An act of witness. The hovering question—what this invokes in me is art. Art, an eternal waterfall thrashing within. A refrain has risen:

Was my mother an artist?

The refrain presumes several things to be true. My mother didn't have a public, or private, formal artistic practice. She used her hands to work through her thoughts and busy herself. My question delivers an incantation, *was my mother an artist*, supposing that I could conjure the relationship I so desperately desired.

Was my mother an artist?

THE LATE LITERARY critic Barbara Christian admonished Black female writers and critics to avoid the fractured tradition of "fixing" when it comes to approaching a text from a critical standpoint. One could understandably presume that this angle derives its crust from Christian's library of knowledge and her literary scholarship. Craft over content, content over character—the experience of prescriptive edits and problematic critique (in the case of the art school crit or the writing workshop) usually comes to the same distressing end where one's character is up for scrutiny before the work has been thoroughly examined. This resistance to

"fixing," of course, involves very specific historical stakes for Black women and femmes, and therefore situates itself as protection and a warning against replicating aspects of domination and misogynist social conditioning to "correct"—and solidifies that the case for criticism is often hampered by these fraught lineages. As an adult, anything that might be considered an outburst is typically dismissed with an eyeroll, or worse, a narrowing of the eye, directly into my eyes as if I'm somehow blinded by the spectacle of myself. What I'm saying is how queer I was born, how strange I have always been, and how unable I am to hamper myself, no matter how hard I've tried. What I'm also saying is how much of this yelping interiority is an ancestral transmission. To fix me would be to quiet the frantic ghosts.

But despite my strangeness, much of this shifted when I became a teacher. The missing link was found not in the position of power but in the opportunity to shape and collaborate with the other voices present. Considering that I'm the daughter, sister, and grand-daughter of teachers, I do believe that clarity *from/within/at the site of* the classroom is my destiny. My grandmother was the first to obtain a college degree—man or woman—in her family. My father told me that she got herself a car and a trunk full of groceries when she got her first job. I say "from" because many of us have come to experience the classroom as a site from which conflict, relinquish-ment, and opening can occur simultaneously.

When I teach my students to earn the "I," it began as a reminder to the composition chorus of how we use "I" sparingly, without leaning on it and hoping to construct our analyses first, then incorporate the rest. For prose writers, and those alike, the concept of earning the "I" is not about production or wages or profit. This calls forth a specific kind of attentiveness. When we work with our poems, our prose, our essays, our sentences, we must always ask, what does the poem need? "Poem" is the catchall. This is when the project of the self, self as project, is one of sound and sight, not only words. How does my voice sound? When we activate the sonic accoutrements and the acoustic arrangements, we are making it possible for our consciousness to be stirred but also to ignite, recoil, lend us its softness, its curiosity. For our consciousness to invite curiosity. Mary Oliver teaches that to make your imagination trust you, you've got to turn up every day.[3] Think of it as tending to another soul, a divine persona that, to put it mildly, only you can activate.

Like in poetry, the "I" as polyvocal "we"[4]—briefly unhinging ourselves from the conditions of this world (in our writing, in our thoughts, in our spiritual

3. Mary Oliver, "I Got Saved by the Beauty of the World," *On Being with Krista Tippett*, podcast, February 5, 2015, https://onbeing.org/programs/mary-oliver-i-got-saved-by-the-beauty-of-the-world/.
4. Adrienne Rich, "Someone Is Writing a Poem," *What Is Found There: Notebooks on Poetry and Politics* (New York: W. W. Norton & Company, 1993).

selves, the only place where we can do this), to grasp hold of the hands reaching from elsewhere.

How might the critic consider "I"? What stands between us?

We are believed to be individuals obsessed with culture, whose origin stories involve multipronged pathways—from hallowed archives to working behind the line at a five-star restaurant. Identity forms opinion—context and position—but a critic's education relies on a specific and internal collision, unnamed. While I find the critic's education could certainly be fortified in school, my critical consciousness is surged by an internal engine. Us critics are mostly known for our passion: chasing a pitch or finding our way into the corner of an opening, only to blab endlessly with the person who happened to be walking by.

It is here that the "I" could be relinquished, recovering the "I." To what extent does the discursive, loud-talking critic require lived experience as form, in service of the work?

It is here where I begin to conceive of critics as students, first.

Basquiat's Children

WRITER AND CHOREOGRAPHER Ralph Lemon describes first seeing Jean-Michel Basquiat's work at Annina Nosei's Chelsea gallery as "amphetaminic." A response to being cracked open by enthusiastic recognition, in the face of an unflinching and familiar voice. A voice he could hear.

(*It also made me want to jump up and down with laughter.*)[1]

His description is protected within a parenthetical—a lineage of punctuation as soothsayer, an intimacy.

There is no "I" but a "me"—the "I" can be heard inside the vigorous physical response.

Up and down.

The "me" also assures, indicates ownership: me, mine. Lemon and his energetic expression call to mind a Black child's first Black teacher—a figure whose presence contains effortless audacity simply from the dual positioning of being Black and *my* teacher.

~~Ownership.~~ Kin.

1. Ralph Lemon, "The Prompt," *Brooklyn Rail*, November 2020, https://brooklynrail.org/2020/11/editorsmessage/Ralph-Lemon.

(If you're the only Black student in the class, you can't help but assume that the teacher is always and only speaking to you.)

Up and down.

This is for You. You get to do this too. You are allowed this. I know what You need.

Basquiat as teacher. Basquiat as *mother*?

Some months after my mother died, a friend loaned me Jennifer Clement's *Widow Basquiat*. I nearly finished the book on the subway ride home, engulfed by the author's position as observer. There will always be a palpable scourge in Basquiat's work, the kind that rattles you from the inside, making it impossible to return to who you once were. Basquiat understood that wrangle, an imprint vibrant and vibrating for the young and Black and artist. *Vibrant and vibrating.*

Years later, my wife would happen upon *Widow Basquiat* in the months after her own mother died and would similarly absorb the protagonist-as-watchtower, but with a different result. The word she used was "beautiful."

I wanted more. *Up and down.*

More than beautiful? Could I write from this place? Composure as genre?

For Black people, what-an-image-does-to-us, the medium in which sight becomes vision, when do those observations deliver crucial information, the kind of information that invites my unique perspective?

Am I asking, *At what point does an image relinquish power?*

Las Meninas? Neither recourse nor reason.

Space often withholds, rather than reveals. I will start with why I'm crying. The work of art, Picasso's *Las Meninas*. I am twenty-six. Love dragged me back to Europe in bourgeois retreat.

Tears as discourse.[2] My ruthless pull toward love left me alone in Barcelona. For weeks, I wandered the city alone. But that day in line, I felt everyone's eyes. I begin to cry.

Foolishly I close my eyes to capture drops. Several manage to travel down my cheeks and collect at the nape of my neck. Solitary vessels, each one tracing a myth of silence inside a now laminated gaze. I knew I was being watched. I am always being watched. Tears as location. A Black woman is never alone in her wanderings.

Never mind the bloated lips from last night's rioja, the salt beading at my temples. Never mind the silhouette of my ostrich neck, hoisting up sleepy eyes.

Burned by the immediate tickle, *Las Meninas* was a morsel of recognition that sent me spiraling toward revolution. I left the museum and followed the road to La Barceloneta, to fall deeper into my aloneness. The bronze sand received me—I writhed into a soft

2. Roland Barthes, *A Lover's Discourse: Fragments*, trans. Richard Howard (New York: Hill & Wang, 1979).

burrow, shifting from fist to complete repose, as tiny sand granules flooded the coiled edges of my hair. Wrung out and shivering under the setting Mediterranean sun, tiny voices gathered to point fingers at this overfull well of otherness. I pressed each wrist into my chest, releasing the heat protecting my heart. I hummed, I noised, I finally Opened My Eyes. *My eyes!*

In front of me—a frothy aquamarine blanket, retreating home.

Tears as progeny—a vision. This collision cancels. *It cannot have children.*[3]

To think that Lemon saw these works while Basquiat was alive. To think that Lemon, or any Black person, *survived* Basquiat. Lemon's laughter recounted later, unexpected salvation and enduring likeness forming at our feet.

3. Sylvia Plath, "The Munich Mannequins," *The New York Review of Books*, February 20, 1964, https://www.nybooks.com/articles/1964/02/20/two-poems/.

Chitra Ganesh, *Action Plan*, 2015. Acrylic, hair, rubber, metal (drain), digital print on canvas, 64 × 58 inches. Private collection.

Art, Politics, and the Architecture of the Everyday

If my work is to be functional to the group (to the village, as it were) then it must bear witness and identify that which is useful from the past and that which ought to be discarded; . . . and it must do that not by avoiding problems and contradictions but by examining them; it should not even attempt to solve social problems, but it should certainly try to clarify them.

—Toni Morrison, *The Source of Self-Regard: Selected Essays, Speeches, and Meditations*

Real art has the capacity to make us nervous.
—Susan Sontag, "Against Interpretation"

– 1 –

IT IS A sweltering August afternoon in 2014. Obama is halfway through his final term as president, and America is inebriated with the distracting doctrine of a postracial world, making the question of "political art" a hot topic, as if the pairing of "art" and the "political" was a nuanced point of expansion.

I ask Chitra Ganesh, *How do you define political art?* Ganesh is a painter, collagist, and animator—her

work deals with the future as a space of transcendence and gender liberation. I am in her studio, and immediately, we greet one another with an exuberant hug, like old friends, even though we have never met before this day. She is preparing for her San Francisco exhibition, *Protest Fantasies* at Gallery Wendi Norris.

Do you consider your art to be political?

Her studio is in Gowanus, Brooklyn, and it doesn't have air-conditioning, but the cinder block walls generate layers of cooling. She gives me a liter of cold water before answering. On the audio of our interview, there are several moments of silence where we have paused for long, desperate gulps. The words "political" and "art" thrum against our parched tongues as we repeat them—like dry sponges, growing more brittle with each emphatic use:

art political art political art political art political art political art political art political

This question of consciousness is on every cultural critic's mind. Particularly whether creative inquiry could inherently be charged with the political, or could involve a seriousness that would always need to be uttered outright and made obvious. To which I posed, "Art is political when it predicts our future,"[1] in the published version of my

1. Erica N. Cardwell, "Empathy, Fantasy, and the Power of Protest: A Conversation with Chitra Ganesh," Hyperallergic, October 30, 2015, https://hyperallergic.com/249897/empathy-fantasy-and-the-power-of-protest-a-conversation-with-chitra-ganesh/.

conversation with Ganesh. My editor, Jillian Steinhauer, commented in her notes: *Do you believe this?*

A few years later, Steinhauer reviewed *Old in Art School*, the second book by Black artist Nell Irvin Painter. Painter details her return to art school in her sixties, as a retiree. She is faced with different and somewhat unexpected hurdles ranging from aesthetics to identity; the typical art-school commitment to formality had evolved and now more expansive ideas and simplified pastiche were priority. Identity politics, ostensibly, but without leaving the "margins" behind. To be a Black artist and desire art school would appear to deny (or accept) that art school is an inherently white institution.

Everything is art had now become *Is everything political?*, both questions rather than statements, themselves precarious ideas. Such disparity could consistently be found during group critiques. Her predominantly white MFA classmates' conditioning involved the "common reluctance of non-Black viewers to engage with Black figuration." Painter faced a struggle against conventions with which she was long familiar, the double consciousness of a Black artist, creative within the convention but often underused, drying out under a neglected light.

In her review, Steinhauer cleverly muses, "Being an artist is a social construct, too."[2]

2. Jillian Steinhauer, "A Second Education," *The Nation*, November 20, 2018, https://www.thenation.com/article/archive/nell-painter-old-in-art-school-book-review/.

IN THE FALL of 2006, I started as a volunteer with a young playwrights' initiative called Off the Hook, facilitated by the long-running Red Hook nonprofit Falconworks Artists Group. The program is based in an elementary school in Red Hook, PS 15. Off the Hook's main goal is to create original youth theater. Plays are written by predominantly Black and Brown youth. Their work is performed and actualized onstage in collaboration with diverse professional adult actors and directors. Most of the playwrights are between the ages of nine and thirteen years old, and are often recruited directly from Red Hook low-income housing and the surrounding areas.

Before joining as a director, one of the first Off the Hook plays that I recall seeing was created by a young Black boy. The play was a surrealist fantasy with a human roulette game and conjoined twins. Through the opportunity to experiment as a writer, this young man was able to give life to his wild imagination onstage. Recruitment was crucial to the success of the program—often, program managers would enter the public housing surrounding the school and invite young people to participate. After learning this, I was struck by the possibility of this play never having been written or shared. I also wondered what other opportunities this young man would have had to express himself. I questioned whether emotional access and privilege for creativity

is a public responsibility, specifically for the young, poor, and systemically disenfranchised mind. Then I began to wonder about the ways that I have changed since seeing this young man's work.

I followed this query, now more curious about my role and a given institution's role in the development of the imagination. As a Black child who could rarely sit still in class but was typically the first to finish an assignment, I was familiar with the dynamics of policing and stifling creative voices. In 2015 I got wind of *Shared Dining*, a small temporary exhibition kept in the Elizabeth A. Sackler Center for Feminist Art at the Brooklyn Museum. Though the contents of our interview were never published, I spoke to Elizabeth Sackler, President of the Elizabeth A. Sackler Foundation, in October 2015, a time when communities regarded the Sackler Foundation as a benevolent donor for art, medical, and educational institutions worldwide, many of which carry their namesake: Sackler Wing, Sackler Center. In the summer of 2008, Sackler first visited the York Correctional Institution. What was slated to be a one-day visit turned into a six-week dance program. Early on, she experienced a startling connection with the women, stunned by the nuance and complexity of these creative and yearning voices. Sackler immersed herself in prison-abolition research, beginning with Jennifer Gonnerman's *New Yorker* article "Before the Law" on Kalief Browder. The article was published in 2014, almost eight months before

Browder died by suicide after enduring three years at Rikers without a conviction. In a follow-up piece, Gonnerman reflects on Browder's journey after Rikers, his suicide attempts, along with the media attention and celebrity gift-giving Browder experienced. Her coverage highlighted the exploitation of Browder's newsworthy identity as a Black man and the psychological consequences of a system tailored around silence. Browder's suicide stunned New York City, spiraling into a citywide investigation of Rikers and other detention centers. As I consider Browder, I think of what we don't know about him, the moments we'll never witness and the masterful thinking he will never share with us. A destiny that could have been similar to the young playwright from Off the Hook. A life, perhaps, lengthened by opportunity and access.

Elizabeth Sackler returned to the York Correctional Institution with a PowerPoint of Judy Chicago's *The Dinner Party*. She asked these women—who now called themselves the Women of York—to create their own place settings. Instead of ceramic plates painted with gynocentric motifs, the women used foam plates, paper placemats, and markers, showcasing the limited resources of the penitentiary while honoring the materials that made up their imprisoned lives. Some of the women pulled from personal stories of an impactful woman they knew, an aunt or grandmother, decorating with swirling calligraphy that extended beyond the plates and onto the mats, while others reached into contemporary feminist

history, such as Mother Teresa and young Pakistani feminist Malala Yousafzai. *Shared Dining* was featured just steps away from Judy Chicago's initial feminist foray.

Over ten years later, the Sackler Foundation and their company Purdue Pharma fell into deeper scrutiny for their involvement with the drug OxyContin. And in a historic move, the Tate Modern and the Guggenheim Museum chose to "no longer accept gifts" from the Sackler Foundation.[3] The foundation's entanglement with a drug responsible for an unrelenting pattern of overdose deaths revealed the problematic cycle of philanthropic anointment. It is a bitter yet unsurprising reality, and a validating lesson in skepticism toward institutional and even foundational backing. Did no one ask, where does the money come from?

The impact of displaying the work of incarcerated peoples in a fine-art setting does little to trouble the divide for emotional, educational, or economic access. It succeeds in shouldering the canonical priority by creating space for disenfranchised people to examine the center and recognize privilege for themselves. While the Brooklyn Museum has a strong overall interest in diminishing marginalization for communities of color by showcasing our

3. Alex Marshall, "Museums Cut Ties with Sacklers as Outrage Over Opioid Crisis Grows," *New York Times*, March 25, 2019, https://www.nytimes.com/2019/03/25/arts/design/sackler-museums-donations-oxycontin.html.

artists—such as Mickalene Thomas, Zanele Muholi, Chitra Ganesh, and other queer artists of color—the question of accessibility is deeply rooted in societal personhood, in a psychological belonging as a creative contributor worthy of the exhibition and visitation. What about exploitation? Some critics argued that the Women of York weren't publicized enough or more prominently featured within the museum's wing. The exhibition occupied a space on the landing flanked by a stone pillar that made it difficult to see some of the place settings properly. Other critics found this to be a circumstance where a privileged voice recognized and utilized their privilege to the advantage and priority of the oppressed.

Meanwhile the series' title, "States of Denial," offered hefty foreshadowing. A systemic "state of denial" that capitalism not only upholds but thrives within. Let it be known that an artist's work, across the intersections, doesn't automatically garner connection or credibility because it exists within the mainstream. None of these women will be released from prison because their artwork was displayed at the Brooklyn Museum at the mercy of an ideological next wave feminism. Nor will it honor a sentimentalist concept of liberation from oppression. The impact speaks more to that space of gray between sound and silence. Still, the expression is an important beginning, a moment when the poison of systemic violence effectively infiltrates the exceptional, the

privileged, provoking an examination of what we know to be universal. In short, it builds a new table.

<center>– 3 –</center>

JUST AFTER QUITTING yet another nonprofit job and becoming an adjunct professor, I was invited to moderate a few panels whose topics typically revolved around the evergreen early aughts thesis concerning the role of art and politics. I presume that my invitation was the consequence for my hyperbolic yammering in the twilight remains of a dinner party. The query—a multipronged, intersectional thinking-through—was peculiar in its reach, like a house spewing individual pillars of smoke from multiple chimneys toward the selfsame sky.

What is political art?

Is art inherently political?

What are your personal stakes in making political work?

The question "is art political" is primarily useless; the question underneath usually involves, "does art *need* to be political," or, as Driskell suggested, "socially significant,"[4] when it has been made by the marginalized and/or artist of color? Is it necessary

4. David Driskell, *Two Centuries of Black American Art* (New York: Random House, 1976).

that artists of color only make work that harbors certain implications for its audience?

The word "necessary" rubs uncomfortably against representation. It rolls around in the mouth alongside words like "diversity" and "inclusion." To claim that art is necessary often distills any nuance for the artist and the viewer. In her 2018 *New York Times* essay "What Do We Mean When We Call Art 'Necessary'?"[5] writer and critic Lauren Oyler interrogates the concept of "necessity" when it comes to a work of art. Oyler argues against the instructive morality in favor of the audience experience. I'm aligned with the liberatory practicum at the heart of Oyler's argument, in defense of the wholly experiential quality of art. However, the stakes can never be ignored as far as I'm concerned, when it involves how few women and artists of color have major exhibitions, book contracts, or tenure-track art jobs. While it might be true that insisting that a work of art is "necessary" is a reductive—if also rudimentary—approach to unlearning, a command to wipe the slate of violent discrimination clean by plopping oneself in front of a Basquiat painting cannot be discounted. The matter is as urgent as a child ingesting visual works of art and aesthetic principles that never embrace their likeness.

5. Lauren Oyler, "What Do We Mean When We Call Art 'Necessary'?," *New York Times*, May 8, 2018, https://www.nytimes.com/2018/05/08/magazine/what-do-we-mean-when-we-call-art-necessary.html.

Dismissing Oyler's article as anything other than white feminist commentary seems legitimate, in favor of the audience, and, as she describes, "a way to waste a few hours on a Saturday." Nearly five years later, I can't help but acknowledge the very clear sense that at the heart of her argument, Oyler and many others harbor a marginal dismissal toward any heightened political stakes for themselves or an audience. I found her Sontagian thesis to shirk any need for art to hold responsibility at all. This is when the point gets lost; this is when the erasure occurs. However, Oyler's indignance occurs alongside a larger point about visual culture and what we *want* to see and what we expect artists to produce. Making a living as an artist collides with a mandatory tone. Beauty and entertainment contain the most immediacy for constructing culture and our framework for engagement. Sculptor Maren Hassinger's comments on this from the late nineties still ring true today. Her comment appears in an interview from Howardena Pindell's collected essays: "In short: There's more representation now, I'm not sure if people of color are making more money. I'm not. Minorities who do not specifically and frantically address their difference may not be getting money and opportunities like the ones who do express rage."[6]

6. Howardena Pindell, *The Heart of the Question: The Writings and Paintings of Howardena Pindell* (New York: Midmarch Arts Press, 1997).

A similar conflation is made with "political" and "social justice." Subsumed in didacticism, "social justice" prioritizes *advocacy and human rights*. A sticky phrase in fine-art circumstances, "social justice" is the political information involved in contemporary art, looking with an awareness of one's condition and acknowledging the conditions of creating underneath the white gaze. Concepts of social justice are intent on this disruption, and critics of "social justice art" often find it to present a willful limitation, a container for the work and a rubric for looking. I find scholar and art historian Nicole Fleetwood's approach to carceral aesthetics to indicate a deeper conceptualization of the condition of making art.

One might determine that considering a work of art in this way encourages a discussion of identity politics,[7] an inevitability that institutions of fine art are built to avoid. Historically, fine art often refutes alignment with works of art that discern implication as an affront to the structure it claims to deny. A calling in and a fuck you. While it is understood that Black artists have often had to historically malign ourselves to be seen and adequately engaged with, in recent years, we are made to believe that this argument has changed.

7. The Combahee River Collective, "A Black Feminist Statement," in *All the Women Are White, All the Blacks Are Men, But Some of Us Are Brave: Black Women's Studies*, ed., Gloria T. Hull, Patricia Bell-Scott, and Barbara Smith (New York: Feminist Press, 1982).

PRETTY SOON AFTER I moved to New York, my tender suburban edges were roughed up by the demands of living in the city. I couldn't roam around all day. I needed a job. Immediately. No one in my life understood how to *live* in New York. That $100 would dissolve instantly and you would need to figure out how to get more money. Finding work initiated a tumbling rotation of identities to make ends meet. Waitress stuck for a long while—once I got good at it, it was a fast way to make money and friends. Each restaurant became its own good-natured, misfit family for better or worse—all of us lonely enough to believe we wanted to replicate this already fraught dynamic. Still the disruptor, I felt that my role was to mess this up. I was a little too weird, a little too needy. Or just close enough to disappear after latching myself on to another crew, trying to repeatedly replicate the surge of belonging the city served me.

I waitressed off and on throughout my first decade in the city. Few movies capture this exhausted grit of restaurant leftovers spread between three meals or having to pay just enough to get your lights turned back on; I had concocted romantic narratives in my head. I always think of *The Goodbye Girl*, particularly the scene where Marsha Mason drops the bag of groceries and weeps over the broken carton of eggs.

Being out and queer in New York certainly elevated my sense of belonging. I could have never envisioned the version of myself making out with a date on the West Fourth subway platform, high off the fumes of being seen. It might have been ten p.m. or two a.m. I was in my late twenties, out to myself and not caring about who saw me or who I needed to answer to. We had just come from climbing all over one another at the pier. Now we were flanked by a handful of onlookers trying to catch the train. This wouldn't stop us. Her soft arms and timid smile, the smell of salt and sky at the nape of her neck. At one point, she pulled back and took a long look at me, licking her lips, eyes scanning those fixed in our direction. I couldn't tell if she was afraid or if she wanted to make sure I was okay. I was daring that night, wrapping my leg around her hip to pull her in closer. Part of the fun was the looking. Especially because it was New York, and most folks just continued past us, going about their business.

IN ONE OF the final questions from my 2015 interview with Ganesh, "Empathy, Fantasy, and the Power of Protest," the artist responds to the question of political art. The header image is of the painting *Action Plan* (2015), a large portrait of a Brown woman with a gas mask, her braid, hovering above the canvas, made of acrylic, rubber, and hair.

Ganesh told me, "This is something that I've felt challenged by differently during my practice, because

a lot of people think of political art as being didactic, both artists and audiences. But I think people that appreciate art and see it on the street don't have any problem with that didacticism—murals, for example . . . It becomes part of the sights and architecture of the everyday."

"The architecture of the everyday" considers the quotidian nonsense we absorb on our commutes or while we stand in line at the grocery store. My relationship to "the everyday" was itinerant and ever evolving. Within the "everyday" I heard the word "local"—*Los Angeles Times* critic Carolina Miranda defines "local" as "to understand my city's language and deploy its slang."[8] Being a New Yorker is political identification with place, a way of perceiving "local" or "everyday" as integral to my understanding of self.

It is where my instincts are sharpest and my voice at its peak. It is that late cab ride home, when I fell asleep, only to wake up in front of my apartment frantically looking for my wallet. When I asked the driver if I could run upstairs to borrow cash from my roommate, he locked the doors and sped down the street. After a few stop signs, I managed to unlock the door and run. The surge in each step that pushed me farther away from him is contained within my relationship to the city. Surely it is in this fight, that

8. Carolina Miranda, "Going Local," AICA-USA Distinguished Critic Lectures speech, The New School, November 10, 2020, https://www.veralistcenter.org/events/carolina-a-miranda-aica-distinguished-critic-lecture.

lived and also *shared* inertia that teaches us to sing the same song. But my fidelity to this place did not come without *dis*placement, or earning my stance alongside of so many others.

In a humorous correlation, my relationship to the town I grew up in would potentially be described in therapy terms as one of "no rapport," a phrase most often used to address issues within biological family. I reach for such terms because the city feels woven into my conceptualization of self or the making of who I believe myself to be. These foundations feel firm and important and for a while required some of the absurdity one might aggressively claim when wielding place as identity. When I left New York City, after over twenty years of living there, I felt lost without *my* city—a condition primarily tied to losing my mother so soon after moving to New York. *My city.* I didn't know who I was without this place, and over those twenty-odd years, I learned to be afraid of finding out.

A friend suggested that I needed to connect to an identity that wasn't contingent on place. A jagged sneer rose inside my chest. I cleared my throat, and rather than engage I did what I usually do: turn my head away from the strained thing and puff out a befuddled but agreeable "huh," the well-honed nonreaction of most women and femmes. The concept felt peculiar to me, like walking up to a stranger and handing them your wallet and then walking away without looking back. I had long been committed

to a version of myself that was contingent on living in New York. *I am a New Yorker*. And then, almost without realizing it, I left. That's how simple I wanted it to be.

Goodbyes are torture, and I didn't know where to begin. I now live in Toronto, a city with a different disposition and no semblance of the passionate, often embittered notes of survival I thrived upon. I don't call this place home. I struggle with the word, like so many of us, unsatisfied by its clean oversimplification of a life. I am still nursing my allegiance to New York. I never wanted to be among the people who left the city because I used to believe those people to have given up. It wouldn't be a long shot to experience their departure, stranger or not, as abandonment, claiming the final breaths of a fervent identity.

New York raised me. There was no other place. Many characterize the city as a woman. A mother. Sometimes a lover, the ultimate top, or a high-femme top, to be exact. The city is the boss before anything else. I found myself in the city as a motherless adult who had left her mother in the first place. The distinction is undeniable now that my father has passed. I left my little town and my mother had no one there to look after her, just fending off the negativity at every turn. Then years later when I moved to Toronto, my father began to fade, and he passed before I had even lived there a year. What I do know is that the challenges that my parents were facing

had been there long before me and without my doing. I couldn't save them, and I will always resent this. I will always consider my pleasure to be inferior to the pain they each endured.

I am responsible for my umbilical relationship to New York. I have always held tightly to the sense that I owe the city, my other parent, something, and anything I feel that I am owed must be earned, an abusive mother-child relationship scenario where one cleaves and the other worries. I want to think that I interrupted this legacy by moving away, trying something new and for myself.

At some point, my mother and New York swapped places. At some point, I was no longer talking about my mother.

– 5 –

AFTER YEARS OF PhD applications congealing under my bed, I found myself working in nonprofits as an art director at a queer youth organization. The transition into this work came after my second summer in France of equal parts secondhand clothes and secondhand lovers atop the stringy tobacco threads of my French cigarettes, unable to distract myself from making a life elsewhere and instead receiving and enjoying the one that I had.

One major part of my job as art director was about persuasion. Better said, convincing. How do

you make the case to funders that an art program for queer youth is an urgent and moral need? That disenfranchised queer youth of color need consistent funding for their art programs just as much as anyone else? I was often met with concern about conduct in art museums, about inconsistent attendance, that "meeting youth where they are at" would never produce enough of a show. The romantic presupposition that traditional art making involved formal skill, well-honed instincts, and exposure to classical training dismissed the beautifully compulsive paintings, the renaming works, and the handmade clothing that filled our art studio to the brim. There was a value judgment that believed talent and skill weren't the same as desire, and that a certain "yearning," as bell hooks describes, wasn't worth cultivating.

My work was to prove the efficacy—how and why the need for arts funding was somehow greater for LGBTQ youth. This would be quantified by the rates of suicide, homelessness and houselessness, rejection from biological families, and mental-health struggles. It was rooted in some harsh truths, but this never seemed to be quite enough *proof*. The work had to be earth-shattering and transformative—every time. The ordinariness associated with a simple clay sculpture and unfinished portrait did not fulfill an evidence-based quota. This was never proven because it can't be. And this model wasn't specific to this organization.

This viewpoint infected me with another personality. I stood outside myself and watched from the same vantage point that I feared everyone else was seeing me from. I managed to stumble in and out of spaces of belonging for the first fifteen years of my life, but my compass was gone and as much as I resisted it, the absence of consistent parenting rendered me naked in my innocence. This became abundantly clear in the eyes of the youth we were serving at the organization. Naturally, my work wrestled open several wounds I'd been poorly covering up for years, and rather than take care of myself, my response leaned heavily on overwork. In fact, over-concern as a disoriented means of caring for myself permeated much of my work there, and eventually alienated me.

I was persistently devastated by the disconnect between the mission of the organization and the intent and pursuit to fund it. So many of us still believed that the nonprofit-industrial complex wasn't as bad as everyone had made it out to be. That there was still some good being done. I constructed a window for myself in the evenings. My writing had always been a sanctuary, but it became even more critical as I attempted to navigate my way out of that space.

At the time I was dipping my toes into art reviews, gingerly launching pitches and writing them through the night after a ten-hour workday, puffing hard on a fourth or fifth cigarette. It was my night job; I didn't

talk about it much. I was finally ready to foist myself upon an art world but I felt ill-equipped to participate, given that I wasn't an art historian. I couldn't help but recognize that the branding of these young artists mirrored the ongoing misrepresentation of Black artists in the art world.

Our group was a gathering space for the uninvited, the voices who would often go nameless. Poetry was a profound opening, a means with which to speak and be in conversation without having to surrender our dignity. Before I could ask the group to write, we all needed to read. During my own long nights, I read Gloria Anzaldúa and believed her words were written for me. Her sense of cultural neglect, her experience as an outsider. My time working in that nonprofit often involved a marathon of programmatic attempts. Some of the ideas were passionately received by the young people, while others just didn't resonate. Here is what worked this time: We were going to do something that looked like school but wasn't school. We were going to read poetry together. We started and finished with Anzaldúa's "Letting Go." Someone's head popped up, pencil in mouth: "This is serious." For a while folks shook their heads lovingly at my stacks of printouts, replacing need for material, slowly nourishing each and every soul. Someone wanted to read love letters the next week. Someone wanted more poems.

The summer of 2013 left us in perpetual transition. As a country, we had begun to reckon with

the ability to assemble images of our life in public settings, in rapid succession. How can we become artists of our lives; how can we curate circumstances? Essentially how can we lie? The biggest lie would soon be revealed when nearly thirty years after Rodney King's beating was captured on video tape, an instance Claudia Rankine describes as the "one we've decided to be the first," Trayvon Martin was gunned down.[9] That summer, the moon traveled with us everywhere we went. I rarely slept because I rarely felt alone enough to sleep. I was accustomed to being visited, but this summer, I often lay awake in prayer. Teaching writing had been a missing link in my journey as a writer, one that I had courted in so many ways.

When Trayvon Martin's killer was acquitted, the seams began to unravel around us. Each young person in the space—some were women, some were not—had a report from the wreckage, stoking the embers in tears and laughter. We needed to make something. But first it was time to read.

There was no need to wave hefty theoretical jargon in front of these young people. It was the reading that brought us together. From those sessions, some inevitable truths rose up: The "I" is the collective voice, a request for new form. Make things up, inhabit other worlds—maybe not of the past, but

9. Claudia Rankine, *Don't Let Me Be Lonely: An American Lyric* (Minneapolis: Graywolf Press, 2004).

a way of looking forward. To insert oneself in that forward motion also beckons new form. And the most important thing: We all want to read together. Read to me so I can read to you. Open the text so that you can join me in this meditation. Let us all read together.

– 6 –

IT WAS MY first time teaching Sontag; it was being read in two sections of the same class. It took me a while to realize how guarded my teaching had become in an academic setting. Previously my identity had occupied a different, more vulnerable plane. I am a Black female professor. There are few of us. And the sad truth to contend with is students know this too.

In "Against Interpretation," Susan Sontag insists that the job of art, and potentially the work of the critic, is to not have a job at all. It is an argument consistently revitalized and counted on to realign the art world when it gets too "reactionary" or "stifling"[10] or caught up in overwrought framing.

Many voices in the first class believed themselves aligned with Sontag and displayed a sense of relief at not having to make or view art that was "political"

10. Susan Sontag, *Susan Sontag: Essays of the 1960s & 70s*, ed. David Rieff (New York: Library of America, 2013).

in context or intention. The other class, after being initially distracted by her tone (described as masculinist and deliberately difficult to connect with), found her commitment to highbrow and unattainable forms of both making and looking at art to alienate. Despite each class holding different opinions on the essay's likeability, only one remained ambiguous (the latter) about meaning making as viewers and critics, while the other class (being led by predominantly white students) insisted that politics, meaning, interpretation were for the birds. What was clear: all these students were negotiating their relationship to the institution, some more skeptical than others. Like a political debate, the students had chosen, hopefully evolving, sides. My students managed to illuminate the inherent stakes lingering near the edges of Sontag's essay—in fact, performed by her.

– 7 –

IT IS SUMMER again. The sticky July engulfs pedestrians in its unrelenting tyranny. Chitra Ganesh invites me for another studio visit before I leave the city. It feels like a surreal ritual, returning to her workspace. Our relationship has evolved beautifully in the years since our last visit. Her father had recently passed that year; mine would die a year later. We had always felt linked at the elbow, like siblings with eyes sparkling, young in front of art. Her studio has also

shifted; she has moved to the brownstone closer to the park, in a push toward pandemic-related privacy, but also for an atmosphere where she can breathe and think more openly.

When I have posed "art is political when it predicts our future," I seek to motivate our way forward. Instead of what art should *do* for us, if anything, it would seem that the art world could be accountable for *envisioning* a direction. A pathway for thinking and looking. Another question from those art and politics panels possessed a different charge—does art *have* to be political? The voices were from a chorus of youth seated in the front row, visitors perhaps, dipping their toes into discourse and weighing intentions. The question asserted, demanded even, a plea in favor of art for art's sake. The question of necessity returns, but youthful, even if it was meant to test its moderator.

The local—in contemporary times—can feel like a conversation around social justice, while the global tends to center fine art. And the local, often rendered secondary to a fine-art aesthetic, is neglected within what we consider to be the art world. A canonical framework advocates for hierarchy, a hovering sensibility, rather than something more perpendicular. A line raked through the center. "Local" is often perceived to be banal or unsophisticated. Self-made and grassroots, without a stamp of approval for intellectual prowess earned by mimicking the old guard in contrived contemporary iterations.

As a Black feminist critic, I often anguish over this divide and want to tiptoe my way through reviews, preempting my entrance, sometimes with excessive polemic and lyrical discourse. This might mean my work is a project of the local, rejecting the conditions of belonging, intent on the political risk.

Wrong Is Not My Name:
A Pedagogy

Crossings are never undertaken all at once, and never once
and for all.

> —M. Jacqui Alexander, *Pedagogies of Crossing:*
> *Meditations on Feminism, Sexual Politics,*
> *Memory, and the Sacred*

WHAT HAD PREVIOUSLY been a raucous overflow of
impetuous, half-baked thoughts transformed into a
self-conscious state of paranoid over*think*. I was in
a new body, and there were no words. Seven years
had passed since my mother's transition. The
number seven is associated with completion; it can
signal the summation of a wearying cycle where one
might be changed near the end of it, just before
entering a new phase. I felt lost whenever I opened
my mouth, locked in a preverbal freeze, like waking
up after a long nap in a place you've never been
before.

Poet and professor June Jordan touches upon this
sense of dislocation in the essay "I Am Seeking an
Attitude" from her collection *Affirmative Acts*. The
book was published in 1998, during Bill Clinton's
second presidential term and the bombing of Iraq.

In 1998 I turned sixteen and saw Lauryn Hill's The Miseducation Tour in Baltimore with my sister. It was my first concert; I was speechless as she performed despite having every word of the album imprinted upon my consciousness.

"I Am Seeking an Attitude" begins with Jordan discussing her hesitancy to describe herself as simply "a woman"—despite her capacity to name herself "a Black woman" in the opening paragraph of the essay.

About which she says, "I don't know why."

She continues, underscoring an important distinction, "Why do I feel comfortable saying, 'I am a Black woman,' or 'I am a woman of color,' but then something inside me pretty serious balks/blanks out when it comes to the more elementary declaration, 'I am a woman'?"[1]

Her framing suggests that her gender cannot be accounted for without mentioning her racial condition. To internalize a relationship to womanhood would be indiscernible without acknowledging her Blackness.

I recognize Jordan in conversation with herself through "Poem about My Rights," in what feels like an answer.

I am not wrong; Wrong is not my name.[2]

1. June Jordan, *Affirmative Acts: Political Essays* (New York: Anchor Books, 1998).
2. June Jordan, "Poem about My Rights," in *Directed by Desire: The Collected Poems of June Jordan* (Port Townsend, WA: Copper Canyon Press, 2005).

Here "wrong" might be a stand-in for "woman"—an act of refusal, but more movable. This language accounts for "seeking an attitude" and a *pedagogy*. A new name.

I, too, might account for the not-enoughness of gender, my gender. Without words, delighting in the ways that parts of me might not be visible to you.

"I am a woman. And I am seeking an attitude. I am trying to find reasons for pride."[3]

Jordan interrogates a way of seeing. A gesture and a turning away. A starting over. The poetics of criticism, a lone streetlight, professing singularity inside a refracted whole.

Eventually I discovered a new refrain. This language, mealy and blooming inside the contours of my mouth. An incantatory murmuring invoking communication beyond archetypes.

> The narrative might naturally progress into the
> Black woman as construct,
> rather than subtly hint at it. I realized this when
> reviewing this manuscript as I rode the street-
> car down Dundas Street in Toronto.
>
> October had become November. The groceries
> have become more expensive.
> The streetcar stops at the traffic light. I look up
> to see you.

3. Jordan, *Affirmative Acts*.

I witness

Septum pierced,
one arm handling a gallon jug
of detergent
 calling in Lorna Simpson's *Waterbearer*
a wool scarf wrapped around

Your neck,
nestled between denim overalls & tiny locs
a canvas tote chock-full of the things you need
leafy greens rest their tails
against your shoulder.

 You don't need me,
 You are walking,

 but I will reveal,
 Your eyes keep light.

there but not there

IN DECEMBER 2022 I gathered with some of my favorite Black femme arts writers—Darla Migan, Ayanna Dozier, Re'al Christian, Lee Ann Norman, Jessica Lynne—to discuss Jordan's critical poetics at the Leslie-Lohman Museum of Art in Manhattan. We modeled the event after the Long Table format, in which "panelists" gather in the form of a dinner party

and contribute to the discussion, potluck style. The audience also participates as guests who take seats at the table on rotation. The hope and prayer were that the evening would tilt naturally into the discursive, informal clamor of someone's kitchen table.

Honoring the Black feminist collective, the museum supported our kitchen table theme by setting up tea and snacks for all the guests, and spreading out newsprint paper like a tablecloth so participants could sketch, take notes, sign their names. The room was packed with curious, vulnerable voices seeking connection. The guiding principle: if you leave the table, be sure to come back.

This was the first of many gatherings. Just after the event began, each writer shared a selection of their work to prompt our discussion. Much of what was shared will remain in my mind, but I am struck by the clear mandate made by Darla Migan:

"My larger project, or *the* project, is telling the truth."

The marked-up newsprint lives in my Toronto home now, in a slim space between my new desk and the windowsill. This desk sits at the top floor of a house, with a view of swaying treetops and chimneys dotting my pensive neighborhood landscape. When I write, I find myself wrapped within a familiar quiet, a light dim, yet somehow still there.

Adebunmi Gbadebo, *True Blue: 18th Hole, 9*, 2020. Black human hair, cotton, rice paper, indigo dye, silkscreen printing, 22 × 18 × 1 inches.

Adebunmi Gbadebo and New Legacies of Black Women's Abstraction

MAGNETIC FIELDS: Expanding American Abstraction, 1960s to Today, a hallmark 2017 exhibition, hails the work of women of color, primarily Black artists. The title references Mildred Thompson's resplendent and infinitely confounding triptych *Magnetic Fields*, and the exhibition featured twenty-one artists—among them Sylvia Snowden, Jennie C. Jones, Candida Alvarez, Howardena Pindell, and Alma Thomas—who reframed personal experience as an aesthetic principle. In their exhibition essay, Erin Dziedzic and Melissa Messina emphasized the central tenet of "nonrepresentational abstraction" as a deliberate shift beyond figuration.[1] Naturally a thesis such as this would confer an intergenerational sleight of artists, many of whom deployed metaphor and intuition as methodical and textual approach.

Nonrepresentational abstraction introduces, often subtly, an act of refusal or even doublespeak— isn't abstraction a means of distilling facade or the

1. Erin Dziedzic and Melissa Messina, eds., *Magnetic Fields: Expanding American Abstraction, 1960s to Today* (Kansas City, MO: Kemper Museum of Contemporary Art, 2017).

dispossession of narrative? Much like jazz poetics, an intentional opacity, distorting surveillance of the white gaze. Untraceable and without location. Private.

If memoir is body, then material is diaspora.

The artist Adebunmi Gbadebo believes the body to be integral to her abstract inquiry. At the time of the exhibition, she was finishing her degree at the School of Visual Arts. Gbadebo describes her practice as rooted in Black history and Black subjectivity, with Black human hair as a main entry point. Her work captured my attention during a press tour at the Minneapolis Museum of Art led by Nicole Soukop, assistant curator of contemporary art. I met Nicole at a New York press event a handful of weeks prior; we chatted across a table about the museum's current exhibition, one which included the harrowing intergenerational survey *Hearts of Our People: Native Women Artists*. At that point, I had gained some traction as a reviewer, carving out a minor niche amid more traditional voices. Still insecure about my lack of "training," but fueled with earnest rigor, I had started to write regular reviews, with commissioned pieces and press releases peppering my inbox. There was a subtle anxiety around "getting away with something," as if I wasn't allowed to consider these works from my vantage point if I didn't have the proper training. I found the title of "critic" ill fitting—not without analytical force or acumen, however, further away from a measure of

value endowed within Eurocentric frameworks. My writing aligned more with study than analysis, so "student" was a category that allowed clarity and openness, a sense of curiosity that I had long felt missing from typical discourse. With each studio visit with a Black woman artist, it was abundantly clear to me that my role was one of service before anything else. As listener and conduit.

The early part of my day was devoted to the *Hearts of Our People* exhibition, led by cocurator Jill Ahlberg-Yohe. Soon after, Nicole walked me through many of the museum's other featured shows, namely the exhibition *Mapping Black Identities*, a long-term, rotating survey displaying works by African American artists whose historical context was emphasized through figuration, movement, and material. Gbadebo was among a few of the emerging artists included in the show; her work immediately caught my eye. In fact, it seemed to call out, *Look at me. I am here.*

An 8½″ × 11″ piece, the size of a standard piece of paper, densely matted with cobalt-blue ink coursing through like blood-filled veins. Sprinkled within the composition, in clumps and rhizomatic threads, were coiled bits of Black human hair. I marched toward the art, ready to inspect the work with my hands. Awareness of myself flashed into my sight line. I closed my fingers back into a tight ball and asked, "Are you familiar with this artist?"

Gbadebo describes these works as portraits; each contains pulverized cotton, denim, and Black human hair. She sources much of her material, the paper in particular, from the True Blue plantation in South Carolina, where her mother's family worked and was subsequently buried. The will and testament of George Pawley, who enslaved Gbadebo's ancestors, is matted and woven throughout each portrait. In an interview at the Clay Studio in 2021, she told me, "Human hair contains our DNA. It becomes a literal way of representing our history, our body. Because the hair is our body, it allows me to work abstractly and really depict them in a substantial layered way."

The first time we met, I was working on a review of Gbadebo's first solo exhibition at the Claire Oliver Gallery. It was late 2020 and my trip to the Harlem gallery marked my return to the subway since the pandemic closures in New York earlier that year. I was wearing a cloth mask made of dark indigo denim with Frankenstein stitch and yellow yarn ties. I bought the mask online from an out-of-work artisan trying to make ends meet during the uncertainty of the time. The subway is a reliable metaphor for the tone of the city. It has an everlasting capacity to shuffle between neighborhoods and social economies with equal parts grime and stench. Despite this, I had not prepared for its new disposition. The number of homeless and unhoused people living on the subway had increased exponentially. On instinct, I reached in my bag to fiddle around for

loose change, but my hand remained there, halted within nearly six months of disconnection. Throughout the ride, I stared into the eyes of everyone around me, overexamining our proximity and choices, bearing witness to the chasm of disparate care within this crisis. Some people wore masks but there were very few. The stakes of social autonomy rendered me awkward and out of practice. I needed everyone to not only protect their own life but commit to the rest of us as well. Without a book, I put on my headphones with no sound, preferring to wallow in silence.

I arrived to a sudden downpour at Morningside Park. I fished around for my small commuter umbrella and leaned against the stone walls of the park with my mask pulled away from my face, finally breathing in Harlem. I missed my city and the way one moves through love and overwhelm within minutes. As I neared the gallery, the sun greeted me, making my damp blazer sticky against my shoulders. Gbadebo was set to arrive a bit later, so I decided to spend some time with the work on my own. The show, *A Dilemma of Inheritance*, contained a collection of twenty-one portraits displayed in rows on the central wall of the space. When Gbadebo walked in, she approached me immediately. "I like your mask."

Warm and inviting, her presence delivered a curiosity about the work that was unexpected. For the *True Blue* series, Gbadebo aligned the number of portraits with the number of holes in the True Blue

golf course of the same name. A student of her own work and process, Gbadebo left me considering the relationship between artist and critic, abstraction- ist and writer, Black women artists as a dialectical imperative.

As we discussed the work, Gbadebo continued to admire my mask. "Where is it from?"

I froze momentarily, unable to recall the name of the artisan and quickly blurted out that I bought it online. She smiled, a loose chuckle animating the corners of her temples.

"You should look it up. You never know how or where things are made."

WHEN I FIRST told my dad that I was publishing writ- ing about art, his first response should not have been surprising.

"So, you mean to tell me that you are going to go see some art on a wall and then write about it?"

His reaction struck a frustrating if familiar chord, given what he knew about my interests, the muse- ums I often dragged him to, and my persistent need to go against the grain. The conversation was over the phone; I was walking down Flatbush to meet a friend. He was at home in Pennsylvania, the TV blar- ing in the background.

Yet and still, I desired connection. I was starting to feel proud of my work, and I wanted to share this with him. He was looking for legibility; Daddy liked being able to brag to people at church and to other

loved ones and family members about anything, relevant or not, going on in my life. Simply, my father wanted what was best for me. I knew this, but I also knew that conversations like this would always be tied up in this legacy of needs. If I wanted to connect with him, I would need to temporarily let it go.

Months later, Z and I arrived at the Harrisburg train station, the sky was an overwhelming gray, wrapping me in nostalgia. He delivered his usual rundown of the recent occurrences about his role as a trustee in his church, an elaborate breakdown of the weather report, and recent goings-on in his small rural neighborhood.

After a slight pause, he cleared his throat before announcing, "Oh. Before I forget"—his eyebrows gathering fervently in the center—"I have had the distinct pleasure of reading your writing, uh, Erica." He cleared his throat again, pausing in his playful way, an emotionality more bashful than sport. He said, "You use a lot of words that I have never heard before. But Z showed me your writing." His gaze remained steadily focused on the road, with a short glance in my direction. He continued on, specifically discussing the work of Robert Colescott with shocked humor, in line with the artist's intended tone. That was a commissioned piece, another short press trip, a completely rare thing that I ran with. Later he added, "You have the amazing capacity to look at a work of art and analyze it. Where did you learn that?"

ART HISTORIAN VèVè Amasasa Clark's definition of diasporic literacy introduces the interrelated dialogical project of shared lived experience between African and Caribbean diasporic legacies. The dialectical project of making within the diaspora assumes, according to Clark, "*the reformation of form*, a replicative narrative posture which assumes and revises Du Bois's double consciousness."[2]

Diasporic literacy acknowledges the many-voiced sensibility of our consciousness. We might not have the words for what we come to know but through tone and intuition it is clear. This concept invokes the literary note of "thinking on the page." If only writing about art embraced this purposeful disconnection, pausing to listen, to briefly capture this stillness. A reciprocity, existent by its antithetical nature.

Clark's theory has recently been elevated by art historian Rebecca VanDiver. In her book *Designing a New Tradition: Loïs Mailou Jones and the Aesthetics of Blackness*, VanDiver poses the question, "How might an artist demonstrate 'an ease and intimacy' with a foreign visual language?"[3] The question arrives in consideration of Loïs Mailou Jones, her shift from representational works toward the abstract. I'm always fascinated with interdisciplinary

2. VèVè A. Clark, "Developing Diaspora Literacy and Marasa Consciousness," *Theatre Survey* 50, no. 1 (2009): 9–18, doi:10.1017/S0040557409000039.
3. Rebecca VanDiver, *Designing a New Tradition: Loïs Mailou Jones and the Aesthetics of Blackness* (University Park: Pennsylvania State University Press, 2020).

artists, but often what becomes more fascinating is the discourse surrounding them, as if art weren't an extension of the ways people change.

I consider, how might a *writer* demonstrate "an ease and intimacy" within visual language? To display critical acumen to our readers, without alienating the audience—or the artist. Critical art writing that is in service of the art, artist, and her people. What Clark might be asking us to consider is how we convey our relationship to the body in the art we make. How the body lends a kind of grammar and, in turn, an organizing principle. Lived experience as form expresses the nature of arts writing as a practice of entanglement. VanDiver also suggests diasporic grammar: "a subversion of the extant grammar decides one needs to other."[4] I find such instinct to display an awareness that you are not working alone. That a certain kind of divination is taking place. Much like the diary. The feeling that someone is looking over your shoulder might be the presence of spirit. The self-consciousness of writing in one's diary needn't be a limitation. Work with it. Respond to what is there. This is in no way validating external voices, uninvited editors, and critics. Rather, writing and making as invocation, writing and making as awareness.

In 2017 the exhibition *We Wanted a Revolution: Black Radical Women, 1965–85* opened at

4. VanDiver, *Designing a New Tradition.*

the Brooklyn Museum. In the accompanying cata-
logue, a two-page spread publishes Senga Nengudi's
ARTIST STATEMENT in a section titled "Dialectics
of Isolation, Excerpts."[5] Her statement exemplifies
diasporic literacy for its priority for lived experience
as an imperative for expressing Black female subjec-
tivity. The statement reads like a poem.

> I am concerned with the way life
> experiences pull and tug on the human
> body and psyche. And the body's ability to
> cope with it. Nylon mesh serves my needs
> in reflecting this elasticity.

I think about this in relationship to what Gbadebo
surmises about the hair in her work: "The informa-
tion in a strand of hair becomes a part of a piece
of hair." How does material communicate with the
artist?

The artist Genesis Jerez works in a similar way—
directed and organized compositions, with specific
materials: burlap, linen, pencil. There is a deep root
story in her painting *Her Maiden Name* (2021), in
which she engages with the still life. But the unfin-
ished characterization offers another way to consider
restraint as a greater sense of materiality. These

5. Catherine Morris and Rujeko Hockley, eds., *We Wanted a
 Revolution: Black Radical Women, 1965–85: A Sourcebook*
 (Durham, NC: Duke University Press, 2017).

artists introduce another framing for Black women abstractionists, one that derives direction not only from memoir but more deeply guided by consciousness. After placing her composition of paper, cotton, and hair, Gbadebo continues to manipulate it as it dries. In our series of interviews and studio visits during her tenure as 2020–2021 Studio Museum Artist in Residence, Jerez said, "I find myself responding to the holes in the paper, letting the work tell me what it needs." She invests a similar attentiveness in her process, describing it as "giving the painting what it needs to work." I'm fascinated with the use of "work"—I find it to suggest a desire for connection. Less production and more process and cohesion. There is story there, but there is also causal determination, an attentiveness to the journey of the work. At times what might appear unfinished or untended in the areas where paint is absent, or lines become visible, actually allows for breath, most certainly consciousness and connection, even if that connection isn't a direct line to the viewer.

MY SECOND MEETING with Gbadebo was a studio visit in Philadelphia, just after she had started a residency at the Clay Studio. It was June 2021; the early summer wrapped the city in an unforgiving heat. Z and I stayed at a friend's rowhouse with no air-conditioning. We slept topless, with a fan whirring hot air across our sticky bodies. My period woke me with ferocity, adding more heat to my stifled state.

I hopped on SEPTA to meet Gbadebo at the Clay Studio. After a brief tour, she brought me to her shared workspace—her focused and congenial studio mates on either side. On the playback of the interview recording, the HEPA ventilation system added distracting noise. Piled atop a corner table were dreadlocks in various shades and textures—ruddy brown, copper, deeper auburn, chestnut—all at rest.

"Some of that is my godmother's hair."

I lingered in front of these living things for a while, as Gbadebo began setting out her new vessels for our visit. My own locs were just six months old. Her process of collecting hair has formed into an epistolary vis-à-vis hair, a unique pen-pal relationship. Typically the hair arrives with a note explaining why the person cut their hair. Or she will receive a DM or email asking if she is still collecting. People learned that she collects hair from Instagram. She had two books with a chart documenting names, location, and hair samples, some of which are from family members, other artists from residencies, and friends. The large bags of hair are labeled with names and locations from 2015.

"When I use the hair, I make a note so I can look back in twenty years."

Gbadebo began making paper shortly after interning for an elder artist who incorporated onion skins and hammered metal into her work. From there, she grew more interested in exploring materiality in

her practice and saw the generative quality of Black human hair as both texture that could withstand a sculptural process and representation. With the use of a blender, she began experimenting with paper making, gluing and attaching hair to the surface of the dried sheets. Gbadebo ruminated, "Can the paper *be* the hair? Instead of taking the cotton fibers and making sheets and attaching the hair, what would happen if the hair *was* the sheet?"

Into the blender went the hair until it became mush. Once it was dry and shaped onto screens, she was left with a sheet of primarily Black human hair. This was an early start for her *True Blue* series.

For this visit, the focus was around her new vessels. Gbadebo was learning to create pots using traditional African techniques with the clay sourced from the land where her family is buried in South Carolina. Not far from the piles of locs were large plastic bins filled with clay. She and her second cousin trampled through the forest to investigate the land where her family worked and were eventually laid to rest. She explained, "They used to grow indigo and rice plantations but after emancipation they started growing cotton."

Gbadebo's family remained connected to True Blue despite never owning the land. Eventually the white landowners seized control of the church and turned it into a hunting club, leaving her family the overgrown cemetery, yet deeming them intruders when they would visit their buried ancestors. The

cemetery, still overgrown, now looks more like a forest. The cousin who showed her around the property will periodically tend to the gravesites, pruning the tall weeds with his son as he awaits a historical marker.

"Even before you walk to the cemetery, there's this bright red dirt everywhere. My ancestors lived and worked in this dirt. Right before you walk into the cemetery, underneath the top layer, everything is that bright red [color]." The bold hue of the clay recalled my brief childhood in Georgia and the soft orange soil like nature's playdough. I would use a stick to manipulate it into curious concoctions of twigs and clay for my imaginary kitchen.

"I just started pouring water in the dirt and seeing how malleable it was."

I asked her, "Had you ever worked at all with any clay?" Video footage she filmed while touring the land shows her working with the clay in that moment, tossing the dry dirt over the wet dirt, kneading and shaping, now with stained hands.

"You know, K-12 art classes where you learn pinch pots?" she said with a smile, and we chuckled together.

Gbadebo continued, "Then came the next question, 'Can I make a series about the very dirt my ancestors were enslaved on, out of the very dirt they are buried in?'"

I insist, "Look at your instinct. You were like, 'Let me try this!' Not a lot of people, artist or not, would

have tried." Later, Gbadebo and her cousin would begin digging; they would fill several containers from Dollar General with dirt from the land.

"I wanted to capture what it was like to be on the land, to stand on the land, to touch the land."

This visit was just a few months before my wife and I would pack our life up and move to Toronto, a surreal decision even as I stood across from Gbadebo. For the artist, it had been a little over a year after she lost several family members to COVID, namely her mother. That day her disposition was effusive, if also somber. There was a sense of needing to work but also of being somewhere else.

Her residency at the Clay Studio is where she began to learn how to work with the clay and coil building. She showed me an early gourd that hadn't been fired. The color was bright, like a new brick. Eventually it will go in the gas kiln to maintain its bright shade.

"I started thinking how a lot of the work we did on the plantations was because of our knowledge and the work we did in West Africa. We worked with indigo for centuries; we worked with rice. We understood that land. And that knowledge was transferred to those plantations. When I went to Nigeria in 2019, I brought home all these vessels and gourds. The first vessel I made was trying to be an identical replica. Just the idea of transferring the information and knowing to this shape and rebuilding. And each gourd I made slightly changed."

Propped up behind the gourd with a long neck and gramophone head is the book *African Ceramics: A Different Perspective.*

"And, although I'm doing a lot of building with just clay, I do want to make something that is a true hybrid of hair and clay. The body and the land. The history of True Blue is because of this. The body and the land were never separate. We were always working the land. Now we are buried in the land. There is no separation."

Just before I left, she gathered a few small loose clay scraps into an envelope and fastened it shut with yellow painter's tape. They rattled and rolled inside, quickly staining the envelope. I have moved multiple times since that visit, but I keep those chunks of clay tucked into my desk drawer for safekeeping.

THE WEEKEND BEFORE my father was admitted into the ICU, my wife and I got our eyebrows threaded. Of course, we had no way of knowing that our grooming would prepare us for sitting at my father's bedside in intensive care for most of March. We would joke about our furry faces—my chin, her lip. My eyebrows, her eyebrows. "It's my culture!" she proclaimed, face fixed in the bathroom mirror. Into her eyes I would croon, "I like your hair. I married you, your hair, you don't need to change a thing," a silly little sonnet, hoping to dispel her concerns. We had been living in Toronto since the summer, nearly six months; the recent wave of Omicron had

renewed our nervousness about salon settings. She turned to me and said, "Do you think you're brave enough?"

I received a phone call in the middle of the night asking if they should continue to resuscitate my dad. A frantic ten hours would unfold into a torturous three months of multiorgan failure and, ultimately, my father's demise. Those months were an incredible nightmare of back-and-forth between Toronto and the Maryland hospital where he had been admitted, the majority of which was spent by my father's side.

The hospital was in a massive collection of buildings that took up nearly three acres in the east end of town where I grew up. When I was a kid in this town, the complex hadn't yet existed. I was among the many generations of young people of color who grew up in a place desperate for culture. And it still was. But now there was an Afghan community and an international foods market. More than one Mexican restaurant and a completely redesigned library. In the following weeks, Z and I would memorize the drive to the hospital in a sleep-deprived rotation in the wee hours, like tending to a hungry infant, forgetting the foods we'd eaten the day before, satisfying my father's desire for a Coca-Cola and the local newspaper, and seeing a new generation of small-town jocks clutching their phones while ordering tzatziki and sumac fries. I would drive along streets that I have no memory of. Memory is strange that

way, but what confounded me more was how lost I felt, toggling between my adult self with doctors and the confusing cadence of being the child.

Just beyond the ICU was a long hallway, facing north, displaying the auburn horizon. I sat in the waiting room and stared at the highway for a long while. Tiny lights dotted my field of vision. Some dissolved, some instantly disappeared. A red blaze flooded the sky, flushing the blue with deep rouge in a rich mixture of burnished indigo. We left those colors behind us on our drive home; the kitchen window where we stayed also faced north. I slept terribly those nights, my neck and chest swollen from the stressful chaos, chin fuzzy again, unable to discern rest. Each day I limped more, my right hip appearing to curve inward for safety. After about a week of this, it snowed—heavy sheets of thick, cottony powder. Days later the snow was gone, leaving only the dirty roadside remnants, like stained foam.

Eventually my father was given an aide. This person had the job of sitting with him. A gift to me so I could work from a family lounge a few feet from his windowed room. There was Vanessa, with the blond extensions. Emily, who took one look at him and declared, "Hi hunny, have you ever wrestled with a big girl?" Mary, who was pregnant and unwell. Kayla, the most competent and capable, who was standing when I arrived one morning, speaking to my dad's weary body, ready to help him urinate. Hattie was grieving her mother and cried through much of her

time, clutching herself as she sat in her chair. Her hip bothered her, too.

After three weeks, my father began to improve. The doctors transferred him out of the ICU and into a rehabilitative wing. Z and I decided to return home to our little apartment in Toronto, praying that his condition would remain stable. It was a strange homecoming: after spending weeks wandering through what was left of my childhood, I had to return to a place unfamiliar to me for different reasons. Such "lostness" contained valleys of isolation that completely consumed me. Nothing was recognizable—my home, my body. Immediately after entering our home, we were hit with a sour smell, chastising our disappearance. The refrigerator contained undeniable evidence from the past few weeks, flaunting a state of rigor mortis that rocked loose the belly of my sorrow. Ghastly layers of white-and-green mold burrowing thick over pulpy carrot and apple juice. Yellowing herbs and greens glistening sweat in their silky plastic bags. And shriveled cucumbers and zucchini rendered slim and small from their abandonment. Time had a wicked, unavoidable calculus. I shoved every last bit into the compost, a strained reunion with my usually precious domestic routine. In bed that night, I wept helplessly. Arms stiff, body limp. Slumped in sorrowful surrender. I wanted to be home, but I wanted to be with Daddy. The nightmare had been real, and it wasn't over.

The days after my father died
I wrote a little letter to my community.
I asked my wife to send it out in an email.
The word I was committed to using was
(in)explicable.
Days after it was sent, I read the email.
I wrote *explicable* instead.
Some desperately call upon Freud.
I think it's more accurate to say that this was deliberate.
A parallel,
with(out) explanation.
Grief as wisdom, grief as clarity.

I DIDN'T KNOW that my dad would die before I finished this book. This truth is most likely only obvious to me. I was 80 percent finished but only 30 percent ready to let it go. My father's nurses described me as a soft soul; at times they would look away from my wide eyes, little baby-bird mouths naked in their need. Those expressions aren't reserved for emergencies. I plod through this life in vulnerable expectation, a narrative that initially labels me as naive. I wonder what becomes of a child who is more than a child, whose curiosity seems dangerous or too precious and unprotected.

From his hospital bed one day, my dad relayed the story of me as a constipated baby too full on bananas; he carried me outside for fresh air, my small chin perched over his shoulder. It wouldn't be long before I puked the bananas down his back, unable to hold it in. He said my mother would fill the cabinets with jars of baby food not because they didn't have food

but as a reminder that they did. Things were tight for my mother growing up, with my disabled grandmother and my WWII-veteran grandfather trying their best to make ends meet. My mother was trying to keep up. In the middle of this story, the doctor walked in and my father lost his breath with relief that he'd arrived before expressing distress of his pain, eyes gleaming, a vulnerable plea to be held in those words. Arguably not always the doctor's job. After he left, my father spent a while describing the doctor's jacket, his loafers with one red and one turquoise stripe at the toe. At this I began to wonder, at what point did these impressions garner value beyond their value to me? I'm curious here in my pathology, at which point do the impressions that create our aesthetics—limited, arbitrary, unique— matter too?

In what would become the day before he died, Z and I drove through the night to be with him at his bedside. I ducked into a back entrance and dragged myself through the turgid smells and soft beeps of a hospital at night. The staff was alert and unflappable despite the heavy blinding lights. My father lay in the corner of his bed, eyes squeezed shut in a desperate attempt to sleep. Instead of waking him, I climbed into a large chair and stared into the faint window light seeping from behind the curtain until sunrise. Soon after, the morning shift of nurses came in to administer his meds. As they refilled his water, my father noticed me in the corner and said curiously,

"When did you get here," still managing to smile at the sight of me. Watching someone slip away introduces a cruel helplessness. You are consumed with the urgent need to make every moment sacred, beyond the simplicity of just being together. In the face of my father's decline, I found my identity utterly remote. I would grasp at moments in which I needed to advocate on my father's behalf, to doctors, nurses, and various aides. But in front of him, I could only slide into relationship. His daughter, the youngest, baby girl. Any summation or desperate final words I could conceive of felt far too removed and, if not, irrelevant. The only place I could find myself was rocking within a desperate state of inquiry. *Is this it? Is this really it?*

When I lost my mother, the absence of "goodbye" was a theft that everyone claimed on my behalf. Now faced with what I can only consider as a glimmer of goodbye, I had nothing but my own proximity to the everyday. Must I believe that I am not without them, my parents, even at death, or could this be the essential nature of survival cracked open, profoundly alone?

The nurse turned the television on and pulled open the curtains to instruct waking hours and assert a routine for patients who rarely make it outside. I surfed the channels as my father dozed in and out of sleep. The overzealous film *The Upside* was playing, which felt forced at best; periodically my dad would open his eyes and say, "Oh, that's Kevin Hart, he's so

funny," before falling back to sleep. While the final credits began, the drumbeat of the Aretha Franklin classic "Rock Steady" rolled in. Both my father and I perked up from within our shared consciousness. Aretha soothed us, recharging our instincts.

Together we chimed in with the hook, "what it is, what it is, what it is," conjuring the language that had always existed between us—instinctual, familial, and very much alive.

IT WAS MAY 16, 2022, a little over two weeks after my dad transitioned. I noticed how much of a toll the whole experience had taken on Z. Subtle lines below her eyes and the late-night whimpers that contained the shock of losing him. With little thought, I sat up one morning and declared, "Let's drive to Philly," hoping to fall into the embrace of a familiar community for a few days. Typically while in Philadelphia, I would visit Adebunmi Gbadebo's studio. I decided to reach out this time, too, despite everything. I felt like it would do me some good, and I knew she wouldn't stand back and overanalyze my proximity to death—pitched like a weather vane as I watched home float away. During those Philly mornings, I spent time editing his obituary in my pajamas before taking long showers. I finished the obituary before our studio visit. As soon as I saw her, I discovered an exhale. We were familiar now—this time, our conversation involved our birthdays and shared zodiac sign.

Gbadebo's studio was now located a little farther away from town, among other artists' studios and warehouses. A textile artist was in the studio across the hall. When I return to the recording, I am struck by how clear we both sound, clearer than the previous recording. It had been fourteen days since my father passed, but my tone conveyed a sense of assurance and ease that I would never attribute to those early days. I would like to believe that being in her space, in the presence of art and process, allowed for release. While this was most certainly true, shock imbues us with a fascinating capacity to cope. This moment with Gbadebo, whose dedication to Black female subjectivity nurtured form, was a new gift.

Now her hair portraits had become wall-sized panels that she created in a trough her studio manager had built for her. The vessels had achieved her hybrid vision, melding hair with clay to configure orbs. And like chapter excerpts made of Black life, each vessel was adorned and fortified with dreadlocks and authentic Carolina gold rice.

"A lot of the cracks are purposeful. How is this using the land. How is this relationship present and not present. I had this vessel that kind of cracked open. It felt like an appropriate opening, like the land pulling apart, these bodies or hair could insert themselves. What comes out of the land, what is in these cracks. Something that comes through. I play with it to the point that it's not just a fully broken piece but allowing that natural crack to happen."

Working with a Nigerian coil technique, Gbadebo begins with a thick coil and winds it around itself. "I like to think of my own body as carrying memory."

Her career had reached a thrilling high. Weeks prior, several of her vessels had been selected for a groundbreaking exhibition on Dave the Potter at the Metropolitan Museum of Art called *Hear Me Now: The Black Potters of Old Edgefield, South Carolina*. The title was taken from one of Dave the Potter's vessels. Her work would be featured alongside Woody de Othello, Simone Leigh, Robert Pruitt, Theaster Gates, and others.

"I have also been thinking about how I'm not just taking from the space but how I can give back. We started photographing the headstones, even the spots not marked by headstones." Each of her vessels takes its title from one of the headstones.

As the sun began to recede, so did my subtle light. The world that I had briefly escaped came rushing back to me with unkind fervor. I pulled my phone toward me to request a ride. Gbadebo took notice and offered to take me home. With generous insistence she scolded me like kin, "You should have asked me sooner! I would have picked you up too."

Our conversation remained lively throughout the drive. When her eyes weren't focused on the road, she would glance at me, preparing to let me know something.

I spoke first, attempting at reassurance. "Thanks for letting me come by at the last minute."

"Oh, I wasn't surprised to hear from you. I was just thinking that I would probably hear from you soon."

I allowed a smile to lift my face. Throngs of traffic spiraled into knotted gridlock. I cracked my window, sending my gaze across the street, into other cars, toward pedestrians ambling their way to safety. With a gentle nudge, Gbadebo pulled me back into the conversation, describing her future plans to return to South Carolina. That sense of strained relief returned, flushing my body with visions of the future. Another studio visit, her growing practice. After dropping me off, her goodbye left me with kind consideration: "Keep me posted on when you're back in town." I watched her drive away, savoring the final moment of this brief reprieve.

Blondell Cummings, *1st Tape*, 1975. Video still from performance
documentation. Copyright by the Estate of Blondell Cummings.

(More) Notes on Chicken Soup

I HAVE A puzzling memory of my mother in a snow-storm in Queens. I am convinced that it is not a dream, but I have no frame of reference for when this situation took place. All that I can come up with is that it was the end of a weekend visit and there were others with us. The storm was freakish and sudden—quickly blanketing the sidewalk with dense powdery fluff like years-old cotton balls. Having very little money, I refused to take a cab from my Queens apartment to Penn Station; winter was a thing to struggle through unprepared. Together, we trudged helplessly through the eight blocks to the subway. No boots, no coats, heads bare. Ice pellets slammed numbness into our faces. My mother wailed in anguish; her cries left me defeated with each slow-motion step toward seemingly nowhere. At one point, I turned to look her in the eyes. The worry they contained is a sight that will never leave me. "You're okay, you can do this," I insisted, words that arrived from a voice unknown to me. She looked back at me, our eyes connecting, a shift washed heat across her face.

I RETURN TO Blondell Cummings with new meaning through the eyes of my students. We were visiting the *Black Radical Women* exhibition at the Brooklyn Museum, and *Chicken Soup* was featured in a small corridor, easy to miss. Students squeezed in and leaned on one another to lay eyes on the performance recorded on VHS now playing on a small television. The picture was hazy and some gave up and moved on to the next installation. But the few that stayed were mesmerized, and one student lingered after the others left, with studied recognition. This caused her to lean in closely, to see her mother perhaps, and locate a history.

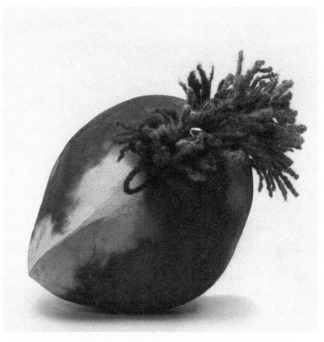

Adebunmi Gbadebo, *K.S.*, 2021. True Blue Cemetery soil, human locs from Aaron Wilson, Kelsey Jackson, and Cheryl Person, 22 × 13 × 17 inches.

If Willarena Were an Artist

Is there a thing where a person can be hung up in themselves?
 —Willarena Cardwell

IN THE SPRING of 2010, *New York Magazine* published a brief profile of the late Sharon Jones where the interviewer used versions of the words "force" and "power" to describe her, an unoriginal observation of her intuition, struggling to convey depth while observing a Black woman. The word "artist" was never mentioned. Sharon possessed an essence, an intuitive part that the interviewer wasn't trying hard enough to identify, a major reason why "artist" holds such significance, specifically when the word isn't used.

Years before this profile was published, I witnessed a white woman testifying at a performance of Sharon Jones & the Dap Kings at Irving Plaza in New York. It was 2006, a Thursday. This woman's fingers were splayed in an arc above us, pursuing the sound, still enough to be alone, warm in the presence of spirit. Her actions said, *receive me*, while the knowing movement of her hips said that someone already had. I wanted her to dance more;

in fact, I wanted her to look at me, as we momentarily believed in the same things.

When I am described as an artist, I feel that the observer sees something in me that is rarely noticed, that any perceived element of nuance informs rather than persecutes, allowing my spirit and intuition to flex muscles of legitimacy. Within this perception, difference is acknowledged as talent and permitted to stand out and be seen.

If you could reach back, arm angled far and deep into the history you've walked through, you might be able to pinpoint the exact moment where anxiety showed itself to you, how it acted on your body.

My mother was in a car accident several years before the one that killed her. My father escorted her home after the accident, her jacket hanging off her shoulders. The white bow that she'd worn in her hair was in her right hand. When they told me what happened, I stood, murmuring concern. I poured her a glass of water. Then I returned to the television.

In that same reach, arm hinging back like the capital letter "L," away from you, trying to remember when you first deemed yourself an artist, where would it take you?

At the performance, my close friend Lee guided me, his hands on my hips, head nuzzling my shoulder. Our eyes rested on this white woman, watching her testify for a long while, even after the song was over.

If my mother were an artist, if Willarena were an artist, she would have been Sharon Jones. I am stunned by my need to call my mother an artist, naive to be surprised by the things that I may not know about her. This connection is risky: Willarena wasn't a soul singer. She was a schoolteacher, born in Nashville, Tennessee, to a WWII-veteran father and Cherokee mother, both the first in their families to raise children who were not enslaved. Sharon and Willarena shared a body—the trim box shape of Black women barely four and a half feet tall, with ivory smiles hovering above their shoulders. They were both women made of gold with a top lip curled under, meant for grooving to a favorite and familiar rhythm. Sharon and Willarena were women that danced because they had to and not because they wanted to. My mother's voice carried the abandon of a child—loud and off-key, often repetitive. *Sing, baby, sing!* she would tell me on long car trips as I murmured along to *The Miseducation of Lauryn Hill*. While working on Rikers Island as a security guard, Sharon would sing to the inmates before her shift ended every night, as per their persistent request. Sharon's voice exclaimed a new life, a second life, one that allowed her to be center stage.

There is another part of me that wants to consider artists as self-identified. The white woman's hand curved and I find this air of connection to be the moment when the music returns, after a period of

silence—a revolution. When you have been working or thinking or cooking and then here comes Nina Simone and her piano, flushing your subconscious with the rhythm of an idea. Could it be the warm thrill of hitting your groove, the way a lukewarm shower in the summertime is both sexy and satisfying, distracting you long enough to keep you in the shower for far too long, far too much water? I'm partial to this psychology, my imagination's hot air balloon carrying me away to that place in the sky where home is no longer visible, and I am momentarily unafraid.

THE MORNING AFTER Sharon Jones died, I woke up to three text messages from my friends gently notifying me of her death. They were the kind of "hate to break it to you" messages that begin with "baby girl" or "I love you sister," sent by loved ones attempting to cushion the blow of a significant ending. The last time this happened was when my mother died. *God was sparing her. He knew she couldn't handle what was coming*, I said to my father the morning after her death. He'd driven overnight; my sister had been calling my cell phone for hours. My voice was even and alert, despite being still slightly drunk from the previous night of partying on Tenth Avenue. The smell of vodka hung in the air, stinging the terrified eyes of my father. We stood in that hollow part of time, moments before it would begin to grow thin, dissolving the lives familiar to us, digging deeper

holes in our skin where fear and worry and doubt were already living. We would become less before we could become more.

In the documentary *Miss Sharon Jones!*, Sharon and her film crew visit a church in Jamaica, Queens. Sharon has just completed six months of chemotherapy treatment and is slowly entering remission. As Sharon climbs the stairs that lead to the church, she pauses after every few steps to catch her breath, easily winded. This is the same body that we searched for at her concerts, when she flung herself on the floor inside of a gyration, only to see her resurface in a bouncing euphoria, the beat reassuring us that she was still there. Sharon walks to the front of the church, takes the microphone, and sings "His Eye Is On the Sparrow." Her voice is a shouting praise; the words form her mouth into lipsticked ovals of overwhelming shock. Sharon seems surprised at her ability to testify. Her back arches, arms wrapping around herself. She stomps; she gives in. Her head flings back, reaching that point in the sky, allowing the tears to spill, catching along her temples, gracefully piling inside of her ears. Sharon's bass player reflects, "She needs the show, that's her therapy, that's the best therapy she can have."

Am I an artist? Which may be asking, are all Black women artists? And while I know that I wasn't merely her friend, I don't think I have ever felt like my mother's daughter, primarily because there wasn't enough time to feel this way, to understand her world as

a part of myself. I carry her remains in order to become. I have listened to people who have lost their mothers speak about them with a particular fondness, of the space in which we find things beautiful, where remembering is enough. Grief will remake life into fiction as you move through it, as the character you embody as you feel sad, especially when the dead never recovered from not knowing themselves. This could be the ultimate tragedy—an ending so extraordinary, it must happen again and again, until the dead are renamed. It may well be the expansive saturation of loss in every space of your life. Or the feeling of a lukewarm shower in the summertime. It is the space where you are at once porous, but also tender and full. Some people become open. Some people make art. Some will even develop a new language or manipulate the meanings of the words we already know and use. These people make brash declarations and think wildly about moonlight and pray for their enemies and consider why art isn't only beautiful.

The author's parents, Archie and Willa Cardwell,
with friends at a Dunbar High School dance.

The author's parents in Paris, in love.

Acknowledgments

WRITING THIS BOOK has been a divine journey of trust and surrender. I have been quite blessed to have unwavering support from an incredible community of loved ones and kinship family. I would not be here without every single one of you.

To my beloved parents, Willarena Cardwell and Archie Bernard Cardwell Jr.—thank you. There are no words for the ferocity of your absence. You are the reason why I write. Daddy, the little scripts and stories I would write that you would transcribe onto your desktop computer from the early nineties. And Mommy, always telling me to write my feelings. I wrote this book to capture the brilliance that you instilled within me, the wild instincts that got me here.

My sweet love, Zhaleh—thank you for never letting me give up no matter how many times I wanted to. Thank you for your steadfast belief in this book, particularly the ways it has shaped me as an artist and person in this world. You have always known this book was bigger than me, and because of this, you also knew that I could never let it go. Thank you. I love you forever. Now, onward!

Thank you to my smart and intuitive editor, Lauren Rosemary Hook. Thank you for your wisdom with this project and your openness to its divine nature. It has been such a pleasure to work in collaboration with you. I know that my parents are grateful for all of the genuine care that you put into this book.

Thank you to my agent, Monika Woods, for your commitment to this project and to my work throughout the years.

To June Jordan, by whom this book is inspired. Thank you for continuing to be a beacon of light as I shape-shift, make new, consider, and reconsider this life.

To bell hooks: Your words are the original light and prayer for Black women critics everywhere. Thank you.

Some of my earliest material for this book was written between 2014 and 2015, in the late evenings after work, in notebooks on the N/Q/R trains, or at coffee shops before or after teaching. Thank you, New York, for nurturing the urgency of an idea no matter where, no matter what.

Thank you to my two earliest readers, Cindy Molina and Stephanie Cowling-Rich. Thank you for reading email excerpts, Xerox copies in front of the coffee machine in the staff kitchen, and so many more fits and starts.

Thank you to Annie Lanzillotto for starting the LOL writing group (Literary Outlaws for Liberation!) in 2013 at Sammy's in the East Village. This group

was truly where my consciousness came back alive after so many years of writing on my own and only for myself. The opportunity to share with Gabriella, Val, Claire, and Audrey and onward into pandemic poetry with Stella and Z had a great impact on how and when I began to call myself a writer.

To Sarah Schulman and our group of writers— Enid, Ros, Morgan. Your fierce feedback helped me generate an early version of "Myriad Selves." Thank you for your continued advocacy on behalf of lesbians, queers, and feminist writers in a world that persistently insists on our silence.

Thank you, Vijay Seshadri, Brian Morton, Jo Ann Beard, Jacob Slichter—my amazing and beloved professors in the master's in writing program at Sarah Lawrence College. I am so grateful for your time and support with my prose experiments and unique approaches to form.

Thank you, Lambda Literary Foundation! The fellowship was a game changer for my life and writing community. I am extremely grateful to Linda Villarosa for always "seeing" my writing and never hampering my ideas. Big love to my 2015 cohort of brilliant loving minds and forever family: Anton, Jeffrey, Lamya, Kayleb, Sarah, Mel, Laura, Todd, Sossity, and Suzanne. That fellowship is where I laid the groundwork for what would become "Chicken Soup: Seven Attempts."

Thank you to my longstanding writing group— Mel, Ella, Lamya, Echo—who waded through many

drafts and versions of this book. Thank you for the late weeknight chats, delicious tacos, juicy gossip, precious secrets, and consistent love.

Thank you to the Vermont Studio Center, which is where I generated piles of writing and wrote "If Willarena Were an Artist" in a wild burst of light. The Banff Centre for Arts and Creativity was where I solidified the critical context of the book in their vast library of feminist arts writing. Big thanks to Daniel Zomparelli for selecting me for Banff's Summer Writers Retreat 2019 Literary Arts Residency, and for your mentorship throughout our time there.

Wrong Is Not My Name is generously supported by the Andy Warhol Foundation Arts Writers Grant, which gave me a fully funded year of deep study and dedicated time. In that same year, I received a New York State Council on the Arts (NYSCA) Support for Artists Grant, which provided me the support to continue my archival research and freelance writing. Through this funding I hosted the Poetics of Criticism in December 2022, the Long Table–inspired event at the Leslie-Lohman Museum of Art, which put me in conversation with some of my favorite writers and critics: Darla Migan, Lee Ann Norman, Jessica Lynne, Ayanna Dozier, and Re'al Christian. Funding as a writer is an unbelievably rare gift that I will never, ever take for granted. Thank you.

Thank you to the 2020–2021 Queer|Art|Mentorship for such an incredible year of healing and friendship at a time when the world had lost so much

momentum from the pandemic and collective grief. Big love and gratitude to Pamela Sneed for sifting through my material and helping me to reintroduce a new organizing principle; to Rio and Matice for not only listening but always, always, always, paying attention to me. Nile and Travis for their generous network. To my incredible cohort of focused change-makers stepping out on courage every day: jess, SJ, Jeffrey, Mev, Brian, Eva, Nandita, Nyala, and our dearest April.

I have been blessed to be lovingly mentored by a host of incredible lesbian writers: Sarah Schulman, Annie Lanzillotto, Linda Villarosa, Pamela Sneed. I have mentioned their impact in my life above, but I do think that the unique form of mentorship from lesbian community is unparalleled and made a significant impact on my book and journey to this moment.

My archival research brought me to the following libraries, collections, and museums: The Schomburg Center for Research in Black Culture, the Art Gallery of Ontario Library and Archives, the New York Public Library for the Performing Arts, the Library of Jan Ritsema at the Performing Arts Forum (PAF), the Brooklyn Public Library, the New York Public Library, the Toronto Public Library, the Minneapolis Institute of Art, the Studio Museum in Harlem, and the Brooklyn Museum.

Thank you to the Ox-Bow School of Art and Artists' Residency for inviting me to teach and for the space to write while Z was in printmaking class.

Z and I will always count that hot August week at Ox-Bow—bonfires, high humidity, silly canoe squabbles, and beautiful sunsets—as one for the books.

Thank you, Kelli Dunham, for the long-running series Queer Memoir, and that incredible first reading where we read our work on the floor of your apartment just a few days after Hurricane Sandy.

Thank you, drae campbell, for curating TELL and making me feel like family every time I shared a story. Big old neighborhood love to you and Memphis!

Thank you to Donnie Jochum and Greg Newton at BGSQD—your bookstore has been such a vital space for queer writers to share new work, giggle loudly, and feel embraced. I read much of the early material from *Wrong Is Not My Name* at the bookstore, and despite loads of apprehension, I was always met with such incredible warmth and support.

Thank you to my research assistant, Sarah Battle, for your brilliant, quick-thinking knowledge of archival research and Black art history.

Thank you to Hayden Bennett and *The Believer* for initially publishing "Kara Walker and the Black Imagination" in 2017.

Thank you to Jessica Nelson for publishing an early version of "Myriad Selves" in *Green Mountains Review* in 2018.

Thank you to the *Kenyon Review* for publishing an advance excerpt of "Chicken Soup: Seven Attempts" in your food-themed folio and *Black Estrangement* issue in 2023.

In the last year of writing and editing this book, I experienced new forms of physical and emotional pain from grief and isolation. I am abundantly grateful to the dedicated practitioners who have been integral to my healing journey: Dr. Julie Hwang, Lamia Gibson, Erin Ladd, Nicole Penak, and Faith Okeke.

ERICA N. CARDWELL is a writer, critic, and educator based in Brooklyn and Toronto. She is the recipient of a 2021 Andy Warhol Foundation Arts Writers Grant. Her writing has appeared in ARTS.BLACK, *frieze*, *BOMB*, *The Believer*, the *Brooklyn Rail*, *CULTURED*, and other publications. She received her MFA in writing from Sarah Lawrence College and is currently an assistant professor in the Department of English at the University of Toronto Scarborough.